IMAG
of Ame

TOWNSEND

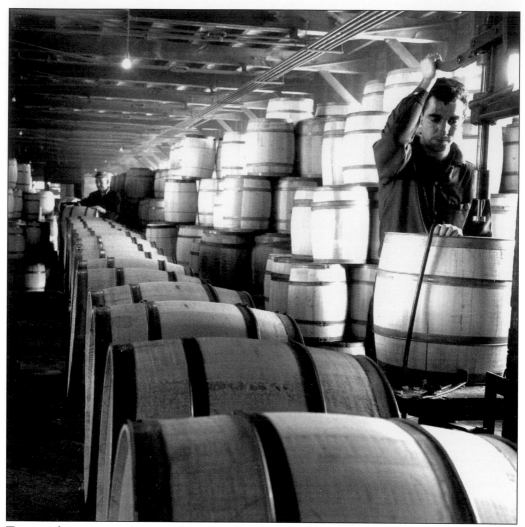

Townsend was a coopering town from its earliest days until the mid-20th century. The B. and A. D. Fessenden Company, Inc., a major Townsend employer for many years, manufactured a variety of wooden barrels, tubs, and pails from 1864 until 1960, becoming one of the largest coopering firms in the nation. Here Manfred Scholes is shown operating a machine to bore bungholes.

On the cover: The Townsend Band is a local institution that originally grew out of the Townsend Light Infantry's need for marching music. Formally organized in 1838, with 20 musicians, it continues to perform weekly on summer evenings. (Courtesy of the Townsend Historical Society.)

IMAGES
of America

TOWNSEND

Townsend Historical Society

ARCADIA
PUBLISHING

Published by Arcadia Publishing
Charleston, South Carolina

Printed in the United States of America

Library of Congress Control Number: 2006924312

For all general information, please contact Arcadia Publishing:
Telephone 843-853-2070
Fax 843-853-0044
E-mail sales@arcadiapublishing.com
For customer service and orders:
Toll-Free 1-888-313-2665

Visit us on the Internet at www.arcadiapublishing.com

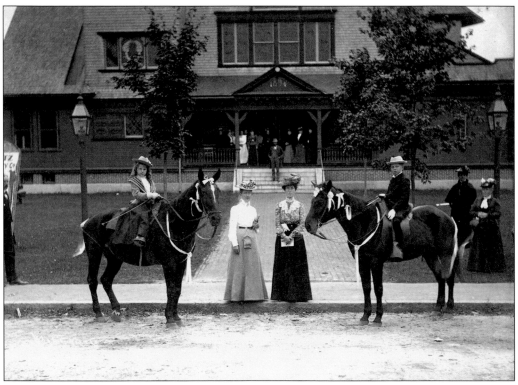

Above is a view of Townsend's Memorial Hall, which was built to honor those who served in the Civil War. Restored to its former glory in the early years of the 21st century, the gracious building has welcomed and served the public since 1894. From left to right are Alberta Barker, Nellie Whitcomb, Minnie Knight, and Harry F. Knight.

CONTENTS

ACKNOWLEDGMENTS

Just as Townsend's history is too vast to be condensed into one volume such as this, those individuals, past and present, who contributed to this book are too numerous to be acknowledged on a single page. Donald Keefe, Charlotte Newcombe, Emily Roiko, Gary Shepherd, Mildred Smith, Jane Stonefield, Alice A. Struthers, Robert Tumber, and Carol Wright are all owed a particular debt of gratitude for loaning photographs from their private collections and sharing their memories and knowledge about Townsend's past; the Townsend Public Library and Memorial Hall also loaned photographs. Such individual and collective generosity has enriched the book beyond measure. A special note of thanks is owed to Donald Keefe, a font of knowledge on local history, who was kind enough to read the completed work with an eye to accuracy. The Townsend Historical Society Book Committee, however, assumes full responsibility for any errors that might remain, despite the committee's best efforts.

In producing this book, the committee referred to Ithamar Sawtelle's *History of Townsend*, published in 1878, and Richard Smith's *Divinity and Dust*, 1978, as well as booklets published by the Townsend Historical Society. William O. Taylor's *Memoirs*, Elsie Lowe's articles and files, as well as numerous memoirs, news clippings, old letters, and manuscripts, collected over 110 years by the Townsend Historical Society, were also consulted. Materials and research provided by Catherine Wilson, local historian extraordinaire, were used extensively. Thousands of photographs were studied for inclusion in the book; regretfully, only a limited number could be included.

The people who researched, collected, saved, and donated materials to the society cannot be thanked enough. Those who have organized them at the society throughout the years also have our deepest appreciation.

In fact, to every Townsend resident—from long ago or from today—who has ever clipped newspaper articles, saved an old photograph, recorded memories, or held on to an old diary, deed, note, or stack of papers, we say thank you. This book could not have been created without you. It is therefore dedicated to you.

Townsend Historical Society Book Committee:
Constance G. Bartovics
Kara E. Fossey
Melinda R. Ryder
Alice A. Struthers
Lonna S. Thiem
Catherine S. Thrasher
Edwin S. West

INTRODUCTION

In the days before Townsend was formed or named, the province simply considered it land "lying in the wilderness on the north of the Groton River at a place called by the Native Americans, Wistequassuck." One man, armed only with lengths of chains and a servant, thrust his way through the feral woods and swampland in 1676. His name was Jonathan Danforth, a surveyor. The province had sent him to mark the boundaries of a political "thank-you" gift: one square mile of prime meadowland for William Hawthorn of Salem. The plot of land would long be called "Hawthorn's Farm," "Hawthorn's Grant," and "Hawthorn's Meadow," but its honored owner would never view, visit, claim, or inhabit it.

By 1719, nature had probably renewed its own claims over Danforth's surveyor's marks, but the House of Representatives expressed renewed interest in that part of the unsettled wilderness. It voted to create North Town (Townsend) and South Town (Lunenburg) to divide a larger swath of land called Turkey Hills. A committee was appointed to "allot and grant out" land, and 72 men purchased lots for 100 shillings each at a meeting in Concord. They had to settle the fledgling community within three years.

The hardy souls that came were especially drawn by the great stands of oak, pine, and birch trees that would prove ideal for coopering, the Squannicook River, and land. Early homes were rough-hewn log cabins, and settlers endured lives of subsistence. Early massacres in Groton motivated the uneasy community to build three garrisons as defense against Native Americans, although none posed a local threat. Even before Colonial settlement, Native Americans had used the land only for fishing and as a thoroughfare.

By 1732, the township held roughly 200 people and a meetinghouse for the intertwined affairs of church and local governance. The province granted incorporation, and the fledging town was named Townshend, after an English viscount, Charles Townshend. Within two years, early residents tamed the river in the eastern part of town, building a dam to power a sawmill and a gristmill. Log cabins gave way to "civilized" wooden houses, as real lumber became available.

While the population grew, the town boundaries changed. A triangle of land in the northeastern part of town was lost to Dunstable after years of bitter dispute. When the province line between New Hampshire and Massachusetts was shifted south in 1741, the township was reduced by one third. In 1767, Townshend's western boundary was moved east to accommodate the newly established town of Ashby. Yet no sooner had the boundary lines been settled than political unrest created new upheavals for the community.

Resentment had been growing throughout the colonies toward Britain. Hard-pressed colonists chafed against unfair taxation, and a rebellion was growing. Townshend residents followed the movement closely, sending representatives to Boston and Cambridge meetings in support of efforts to protect Colonial rights and liberties. They quietly assembled soldiers from their militia

to serve as "minutemen," men ready to march and fight at a minute's notice. When the cannon shot off its warning from the common on April 19, 1775, these Townshend men reached for their rifles and left for battle.

While the war raged, Townshend suffered enormous privations to support the patriot cause. The summer of 1775 had been extraordinarily hot and dry, producing poor crops and epidemics of dysentery and illness. Monetary inflation further strained the cash-strapped population trying to support their troops and help the maritime towns suffering Britain's punitive actions. Conscious of the "nest of Tories" in their midst, residents turned their inflamed passions against the dissidents, staking out their homes and even arresting a handful of them. The vocal opposition was marched to a cooper's shop and locked up for more than a month. By war's end, Townshend had lost half a dozen men to battle, and only those Tories who had opened their purses for patriot efforts were accepted back into town.

Meanwhile, Townshend's name was undergoing a subtle and gradual shift in spelling, possibly as a continued expression of patriot fervor. The infamous Townshend Acts, considered the spark by many for inflaming Colonial passions and igniting the Revolutionary War, had been authored by Charles Townshend's grandson. By 1780, the "h" kept falling from the town's name in the written records, until "Townsend" became the accepted spelling. Local author William Wornham wrote of a childhood encounter with one of Townsend's old-timers happy to share his thoughts on the spelling change: "we knocked the 'h' out o' them British durin' the Revolution and it ain't bin used since."

Despite unifying causes, Townsend developed as three separate villages, each with its own history and character. The eastern part of town, called Townsend Harbor, was the first to be laid out and settled. The Conant family took over the mills near the dam at the Squannicook and set up a tavern in the 1720 house, now known as the "Old Mansion," and the "Conant Tavern." The tavern is said to have been a meeting place for local Tories during the dark and treacherous days before the Revolution. Throughout the 18th and early 19th centuries, Townsend Harbor would grow to become a small but thriving industrial center in town. The 1828 *Gazeteer of Massachusetts* described Townsend Harbor as "a pretty village . . . where is a tavern, stores, a fine mill stream and mills, . . . and the usual appendages of a pleasant country village."

The center grew more slowly, becoming a true center only after the meetinghouse was moved from Meeting House Hill to its current site. The town's boundary changes had affected the location of the town's actual center, forcing the population to adapt. The creation of the third New Hampshire turnpike brought more traffic to the center as well, ultimately establishing the center of town as the commercial and merchandising district, and later, as the industrial center.

West Townsend had built a few mills late in the 1700s, but its early development was closely tied to the turnpike and the village's taverns that provided stagecoach stops. As wealth accumulated, villagers built a Baptist church and later the Townsend West Village Female Seminary. The seminary, which held a fine educational reputation, set the stage for West Townsend's local reputation as the "cultured" and wealthy part of the town.

The rest of Townsend's story is told through the photographs that follow. They illustrate the town's growth from three separate villages into one town. They show struggle, triumph, and the people who shaped the town more than geography or boundary lines ever could. They show efforts to preserve town history, since the past is the foundation for both the present and the future.

This book is not intended to be a comprehensive history; instead it more closely resembles pages from the town's collective scrapbook. The old photographs that survive cannot tell the whole story, and there are always those that are unidentified or undated. Regardless, scrapbooks hold both historical and sentimental value. A long-ago moment of childhood pleasure and the factory office staff are as much a part of Townsend's history as the significant buildings and grand events. The following pages are shared with the reader within that larger perspective and in that spirit.

One

TOWNSEND HARBOR

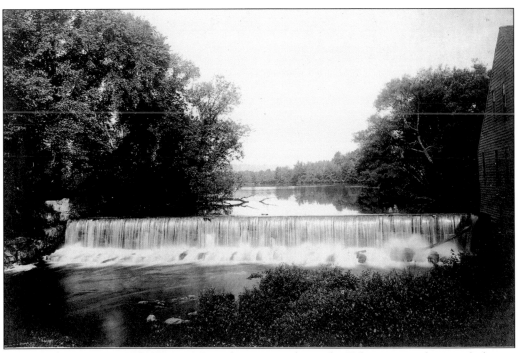

When colonists migrated west in Massachusetts in the early 18th century, they settled near streams and rivers that would provide power for early industry. Townsend Harbor was the site of the town's first meetinghouse, built high on a hill above the river. Later it was moved to a more accessible location. In Townsend Harbor, a dam was built across the Squannicook River by early settlers in 1733. The river, which rises in Ash Swamp and empties into the Nashua River, provided many sites for the mills needed to produce lumber, grind corn and grain, and process wool. The dam was rebuilt in 1870 and carries that date cut into its face, visible in times of low water. The first dam filled a larger pond than was anticipated, requiring the builders to make accommodation to landowners whose property was flooded by the newly created pond.

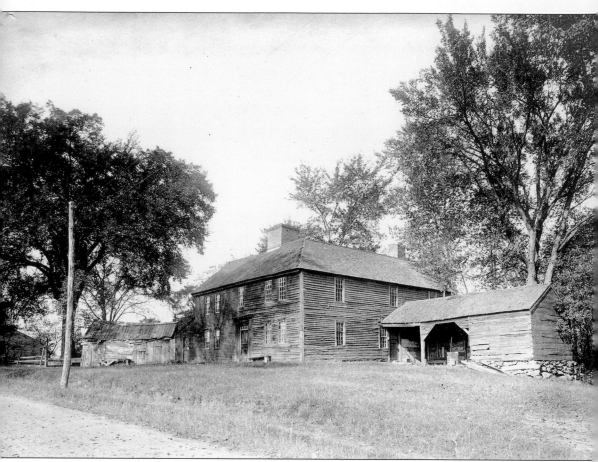

The Old Mansion, also known as the Conant House, at 15 South Street, built around 1720, is one of the oldest surviving dwellings in Townsend. Ithamar Sawtelle, in his *History of Townsend*, attributes its construction to John Conant. In *Divinity and Dust*, Richard Smith opts for John Stevens as the builder. The Conant family owned the house throughout the 18th century and ran the nearby mills that had been built soon after the dam was created. The building was operated as a tavern, and some believe the house functioned as a part of the Underground Railroad. Rescued from decay by Leslie Stow in the early 20th century, it was preserved by the Society for the Preservation of New England Antiquities, now Historic New England, which opened the house for tours. In the latter part of the 20th century, the preservation society reduced its holdings and sold the building to a private owner.

This old trading post was said to have been built before the American Revolution, providing early residents with the means to purchase very basic supplies. Bartering was the primary currency in early settlements like Townsend that relied on subsistence farming. Originally located in the vicinity of 59 Main Street, the building was torn down around 1895.

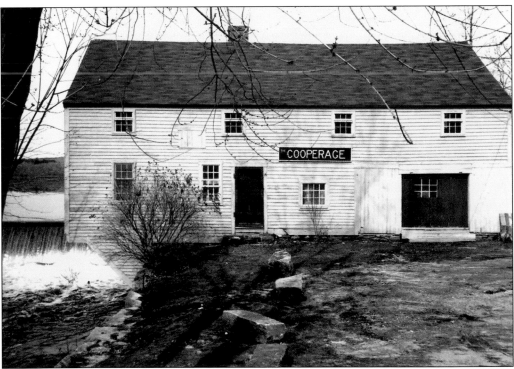

Known today as the Cooperage, this building has housed many enterprises. Nathan Carlton operated a fulling mill in the building before it was converted into a cooperage, complete with a six-sided fireplace. The Spaulding brothers turned it into a planing mill later in the 19th century. The building then fell vacant. The 20th century saw the building used briefly as a restaurant, then as a gift store, which it remains today.

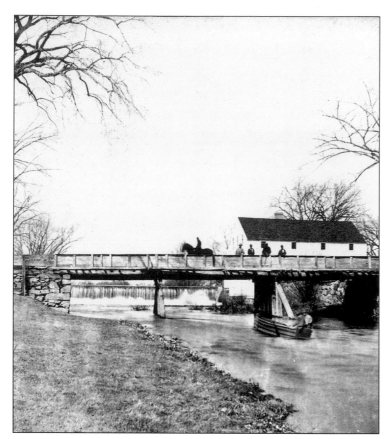

This rare early image was taken from a stereopticon slide, which provided a three-dimensional photograph when seen through a stereopticon viewer. The photograph shows the 19th-century wooden bridge over the Squannicook River (on what is now South Street) that spanned the separation between the north and south portions of Townsend Harbor.

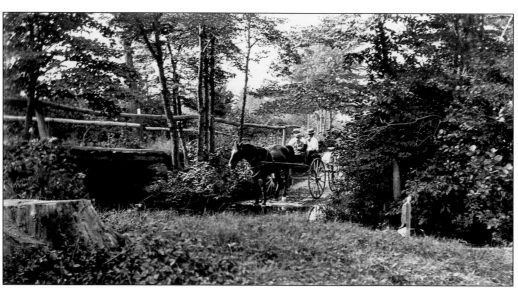

Witch Brook, located in the southeastern part of town, is one of the Squannicook River's tributaries. This late-19th-century photograph shows a couple traveling by horse and buggy over the bridge. The bridge across Witch Brook was washed out in the flood of 1936, forcing school bus driver Richard Conant to maneuver the bus through the water once school reopened.

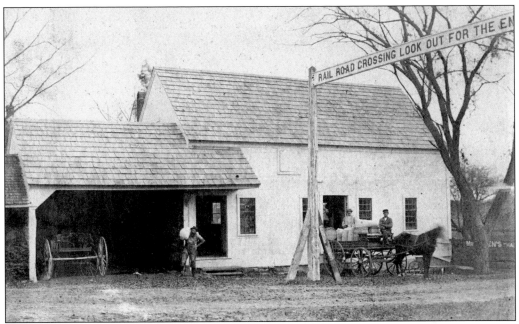

The gristmill, 2 South Street, is shown around 1890 with Ben Morse, miller Edward Spaulding, and John Campbell. Corn and grains to be processed were delivered to the door on the right, fed from a bin on the lower level to the second floor by pocket elevators and down to the grinding stones, and then processed into various grades of meal. (Courtesy of Alice Struthers.)

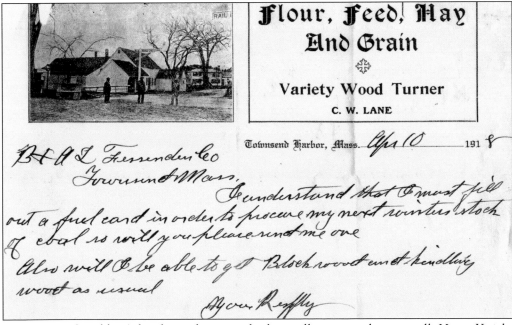

Cyrus Lane, Spaulding's brother-in-law, was the last miller to run the gristmill. Harry Knight reminisced, "[Lane] . . . with his small horse, hitched to seemingly too big a truck, hauling grain for his Grist Mill . . . Farmers from all around brought their corn there to be ground." Lane's letterhead (shown above) included a photograph from around 1900, long before the mill permanently closed in 1929.

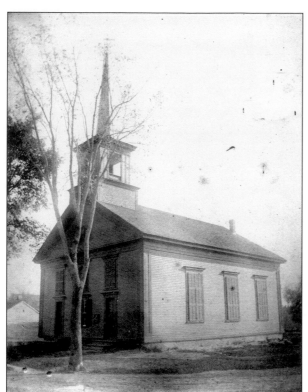

The Harbor Church, 80 Main Street, was built by John Hart and Amos Morse in 1852–1853 for the Unitarians. After a few years, the parish suffered financial difficulties and disbanded, leaving the building empty. In the late 1800s, it was repaired and enlarged to become a community center, where suppers, minstrel shows, plays, talent shows, dances, and parties (including whist and holiday parties) were enjoyed throughout much of the 20th century.

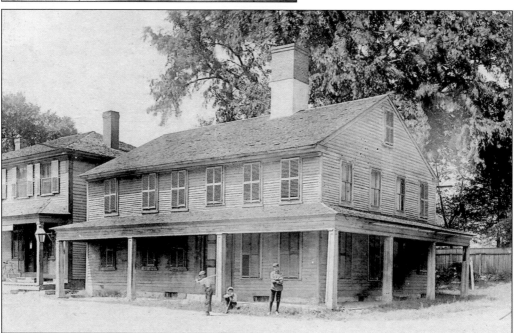

At the crossroads of Spaulding and Main Streets, a hotel and store with a post office were at the heart of the village. Shipley's Tavern was built on the corner before 1822, but the name changed with ownership over the years. Clarence Josselyn was the last storekeeper next door to the hotel before both buildings were lost to fire.

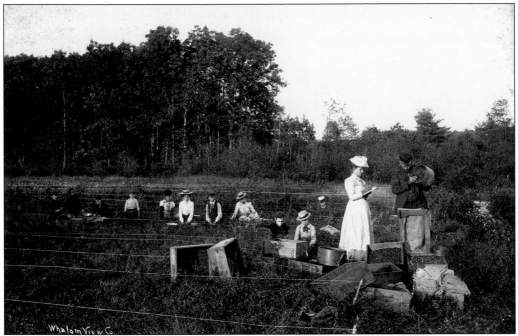

Frank Knight hired women and children to pick cranberries in his bog, located off of Spaulding Street. The *Townsend Tocsin* newspaper of September 23, 1899, reported, "Frank Knight is hustling to get his cranberries in with twenty or thirty hands to help him. He counts on about 50 barrels." The strings shown above mark the rows of berries. Cranberry bogs require intense maintenance, so the site is now a swamp filled with brush.

The Harbor Farm, 81 Main Street, covered extensive acreage and was considered the finest farm in the area. Jacob Hittinger was owner, and the foreman was Michael Keefe. Milk, apples, and many kinds of produce (asparagus was a specialty) were shipped by Hittinger and later by his son, Thomas, to Boston and beyond by train. The Hittinger family also ran an extensive ice business that helped supply the Boston market.

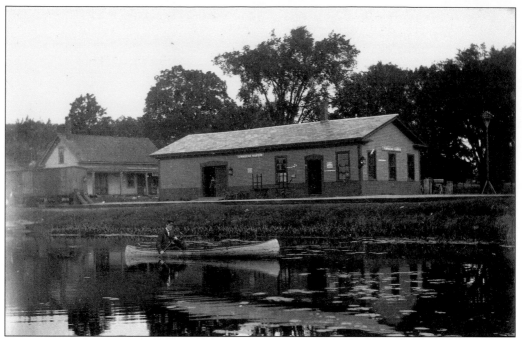

Each of the three towns had its own train station. Station agent Tom Hollihan posed in a canoe in front of the building that served as the Townsend Harbor station and post office, which was located on the bank of Harbor Pond and west of the Harbor Church. The Harbor Depot was torn down and sold as building material after passenger trains to Townsend were discontinued.

Postal services were offered at several locations in Townsend Harbor at different times. Postmasters tended to be storekeepers, such as David Lawrence, who introduced the palm-leaf hat industry to Townsend Harbor, and Lawrence Morgan, who was the town's first rural free delivery operator. Mrs. Smith ran the post office from this building at the corner of Main and Spaulding Streets next to the fire barn.

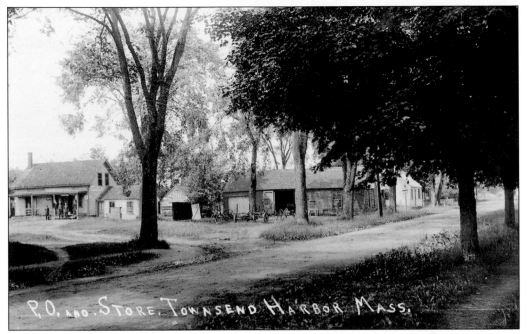

This cluster of buildings, extending from Main Street back toward Harbor Pond, included a store and Frank Knight's blacksmith shop. The Harbor Depot sat beyond the store, out of camera range and closer to the Harbor Pond. (Courtesy of Carol Wright.)

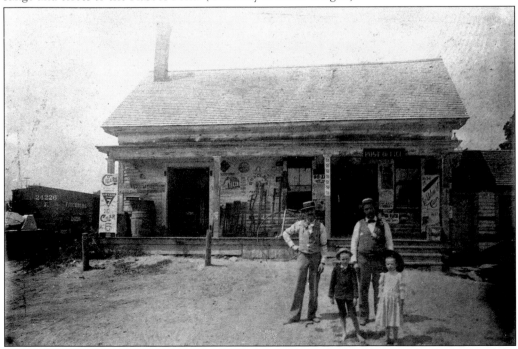

William T. McDonald and owner Lawrence Morgan are shown, about 1894, in front of the general store and post office located in the group of buildings above. The children are Harriett Morgan and Eneas C. Morgan. The store burned on January 30, 1917. "Mr. Charles Warner dropped dead at the fire," reported Eneas, who donated the picture to the historical society.

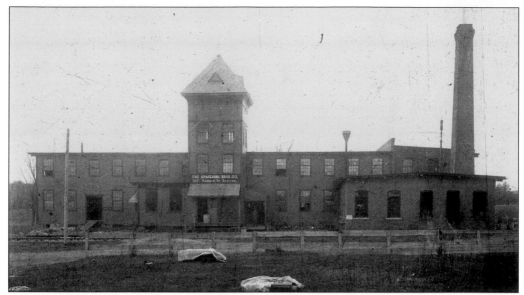

The Spaulding brothers' (Jonas and Waldo) leatherboard factory, whose buildings were strung along the riverbank, across from what is now 55 Main Street, processed leather scraps, paper, and rags into a stiff, cardboard-like material. Scraps were beaten into a pulp and then baked into sheets. The manufacture of parts for women's shoes proved extremely lucrative, supplying markets in Europe as well as the United States. A portion of the factory still stands.

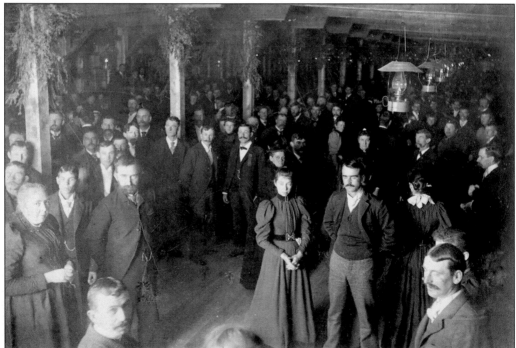

Fire damaged the leatherboard factory twice, once in 1890 and again in 1893. The Spauldings rebuilt and expanded the mill in 1894. The improved factory was dedicated with a gala reopening celebration, or mill warming, held on December 7, 1893. Featuring a concert and ball, the event was attended by 200 couples.

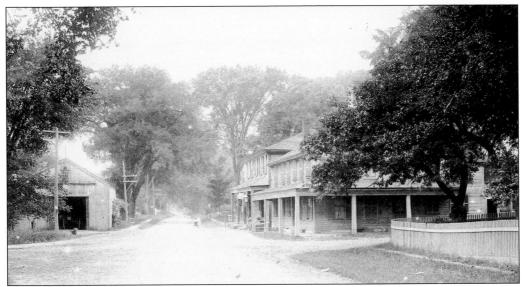

This view of the intersection of Main Street with Spaulding and South Streets shows the barn on the Reed property (left). It burned one night, much to Harriet Reed Strout's astonishment; she had slept soundly through the excitement. Left of that barn sat the first Townsend Harbor fire barn (not shown), perched astride the canal near the gristmill. Fire hoses would be dropped into the canal to siphon up water.

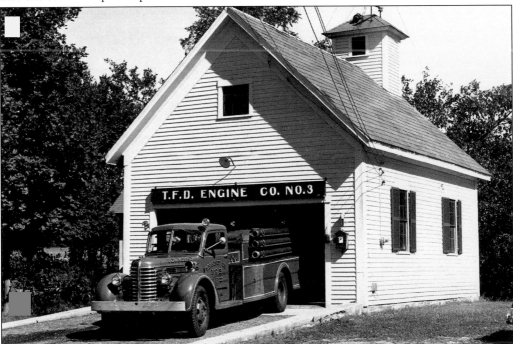

Moved across Main Street in 1930–1931, this building housed Townsend Fire Department Engine Company No. 3. The "Diamond T" fire truck shown was the first new vehicle owned by the station. The tower at the rear of the building, where hoses were suspended to dry out, housed the fire horn. Its blasts at 8:00 a.m. and 6:00 p.m. were a familiar feature of Townsend Harbor life.

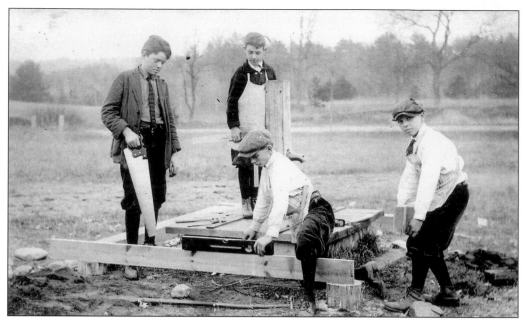

A local paper reported, "Manual training has been instituted into the Townsend schools . . . under the supervision of William Holman of the Practical Arts School, Fitchburg, who will devote one day a week, the same as the drawing and music teachers." Shown here is the first work project—a well house at the Harbor School. (Courtesy of Donald Keefe.)

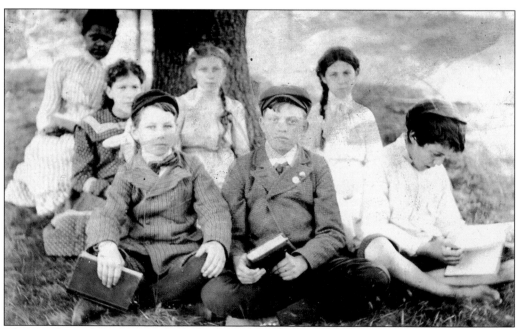

The members of the 1900 sixth-grade class at the Harbor School were, from left to right, (first row) Stephen Keefe, Eneas Morgan, and Ernest Burke; (second row) Isabelle Ewen, Harriet Morgan, and Carrie Burke; and (third row) Mabel Hazzard. Their teacher (not shown) was Adelaide Prime, who walked a mile to the West Townsend Depot, walked from the Harbor Depot to the schoolhouse, shoveled snow, built the fires, and taught six grades.

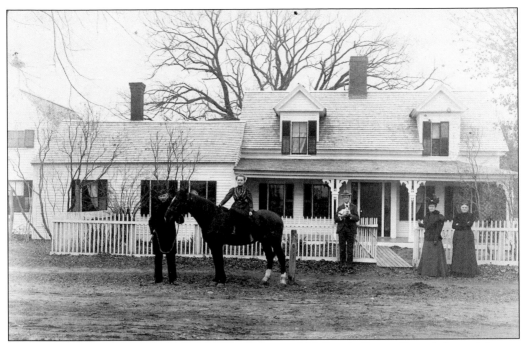

George E. Clark is shown with his family in front of 25 South Street. From left to right are George, Ella Florence, George Jr., Bertha, and George's wife, Ella. As a young man of 17, George served in the Civil War as a drummer and bugler. His war diary was printed in a local newspaper. After the war, he played in the Townsend Band, eventually serving as its director.

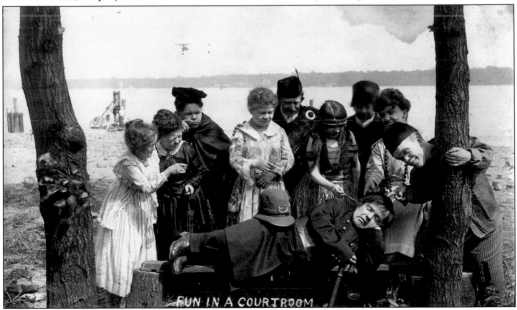

More recent occupants of 25 South Street were midget circus performers George Sullivan, third from left, and Jennie Sullivan, shown tickling the judge's ear. Their residence here during the 1920s resulted in the house gaining the title the Midget House. A trumpet player with a reputation for overindulging in strong drink, George disappeared without a trace from the Staten Island Ferry according to local legend. (Courtesy of Alice Struthers.)

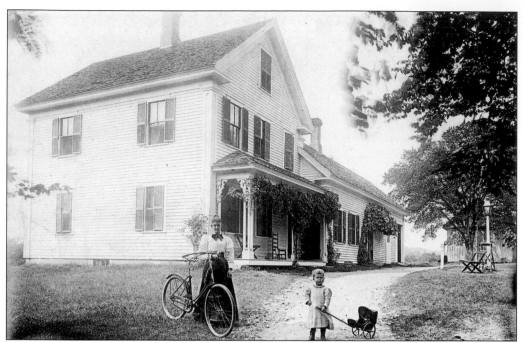

Frank and Minnie Knight were prominent Townsend Harbor residents. Frank's father-in-law, Dana Fletcher, had owned the store on Main Street, and Frank himself ran the blacksmith shop and owned and operated the cranberry bog. Minnie and her son, Harry, stand in front of their home at 6 Spaulding Street at the dawn of the 20th century.

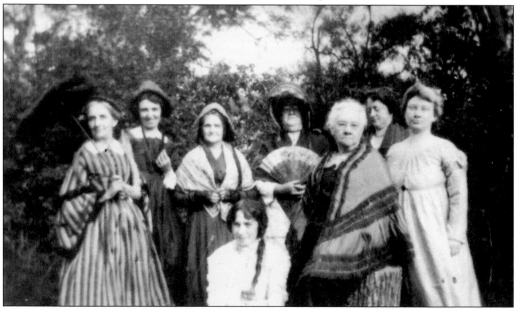

The As You Like It Club flourished in Townsend Harbor during the 1920s. Harriet Reed Strout's Reed Homestead parlor was often the venue for club meetings. In Colonial costume on October 3, 1922, are (front row) Melora Proctor and Hester Proctor; (second row) Harriet Reed Strout; her daughter, Letty Strout Proctor; Ella Frances Cummings; Mrs. Leland Graham; Helen Warner; and Etta Baldwin. (Courtesy of Jane Stonefield.)

Early in the 20th century, 13 kerosene lamps lit Townsend Harbor's streets. They were serviced daily by lamplighters like Cornelius P. Keefe, who filled the lamps using a dipper that held just enough fuel to last through the night. When there was a full moon, the lamplighter's services were not required. Electricity replaced the kerosene lamps in the early 1920s. (Courtesy of Donald Keefe.)

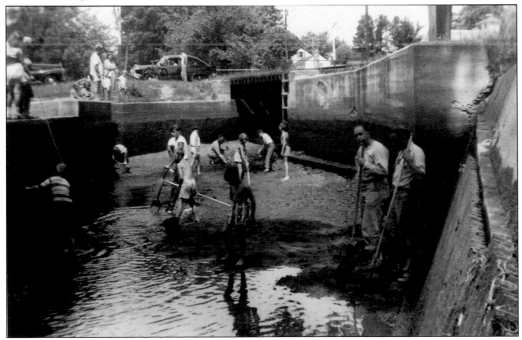

Swimming in the gristmill canal was a bright feature of life in Townsend Harbor. When the leatherboard mill closed for vacation, neighborhood volunteers would drain the water from the canal and then clean it, using rakes, shovels, and pails attached to ropes in order to clear out the debris; children could then safely play in the canal. This photograph was taken in the 1950s. (Courtesy of Carol Wright.)

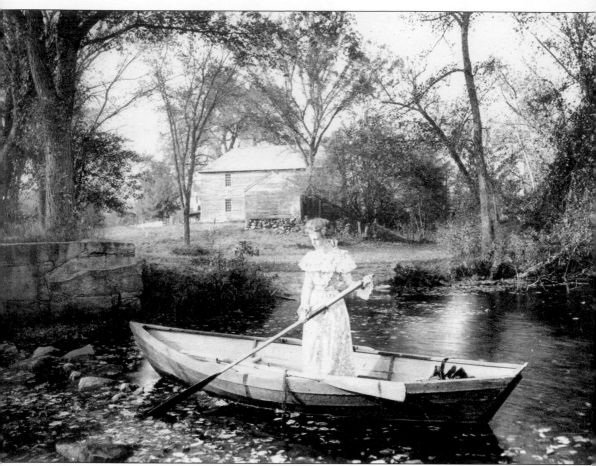

Blanche Baldwin is shown in a dreamy pose in a boat on the pond near the Old Mansion. Catherine Wilson, a descendant of the Proctor family, lived for many years in Townsend Harbor. In her paper, *The Harbor Pond and its Influence 1732 to 1983*, she writes, "Artists and photographers find the pond a desirable subject to depict. About 1902 Blanche Baldwin posed in a rowboat beached on the dam. The photograph graced both a calendar and picture postcards. In 1960, a color photograph of the dam and pond in October splendor was selected for an advertising calendar. Every year or two a picture of the dam with the Cooperage in the background appears in local papers, usually with ice, snowdrifts, or high water cascading over the falls. Many people have slides of beautiful sunsets reflected on quiet water." A copy of this picture was discovered in a rooming house in western New York State and donated to the society. The Baldwins were an old Townsend Harbor family. Life Baldwin established the first store in Townsend Harbor on the east corner of Main and Spaulding Streets.

Two

TOWNSEND CENTER

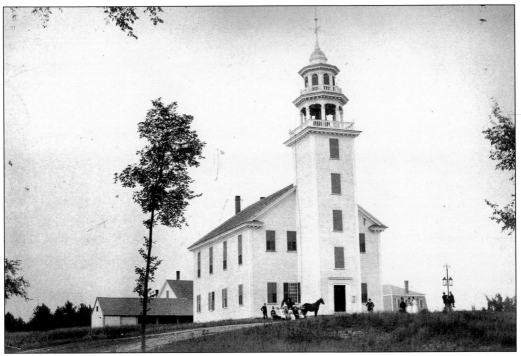

Now the Methodist church, the town's second meetinghouse was built in 1771 on Meetinghouse Hill, once called Mount Grace. The building was moved by teams of oxen in 1804 to the town center, where it sits today. It once served as the seat of local governance and worship until church and state separated and alternative denominations edged into town. The Congregationalists moved out to build their own church, and the Unitarians took it over until the parish dwindled dangerously. The building was then sold to the Methodists, who turned it to face south instead of west and undertook extensive renovations. The first floor was rented out to the town for meetings, business, and entertainment, while the second floor was the sanctuary. The town hall remained on the first floor until Memorial Hall was built in the 1890s. Visible in this photograph are the horse sheds behind the church. Not visible are the old slave pews inside, located at the top of a separate staircase leading above and behind the congregation.

William Clark, a shoemaker from Concord, was among the first 72 individuals to purchase land in 1720. Sometime before 1742, he gave one acre of land to the town for a community cemetery. The Old Burying Ground, once known as God's Acre, is located on Highland Street and contains inscribed gravestones dating back to 1745. Here lie many of Townsend's earliest settlers and Revolutionary War patriots.

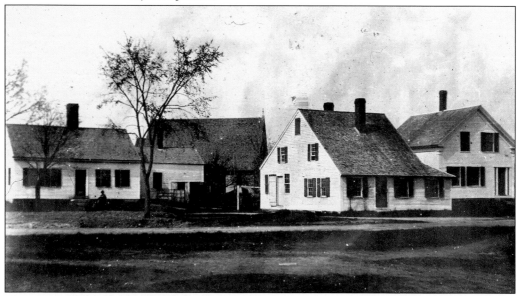

This view of the north side of the Townsend Common includes the old noon house in the right foreground. A noon house held four rooms, each with a fireplace. A Colonial family could warm up and eat dinner between the morning and afternoon services on Sabbath day. The building was moved to Highland Street in the 1890s and converted into a home. Although greatly altered, the house still stands.

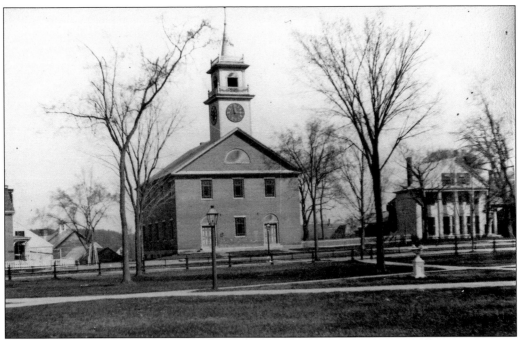

The Congregational church was built adjacent to the common in 1830, following the split between the Unitarian and Orthodox Protestant faiths. The Unitarians kept the meetinghouse building, and the Congregationalists built a new brick church. A portico was added to the latter in 1931, a gift from Rev. David Palmer's granddaughter, Mrs. James Doane. Reverend Palmer had been pastor during the dissension between parishes more than 100 years previously.

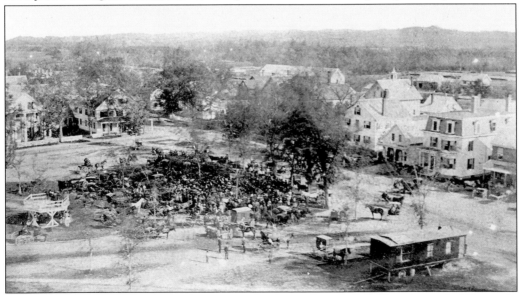

The town common has been used as grazing land, a militia drill field, and a park. This early view, taken on Memorial Day 1873, shows the southeast corner of the common and the raised open bandstand. Band concerts, Chatauqua presentations, fund-raisers, and fairs have all been held on the common since the Methodists donated it to the town. Generations of children have considered it the community playground.

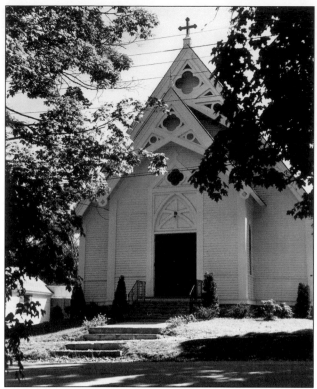

Catholic families in Townsend had to turn to Fitchburg, then Groton Junction (Ayer) to worship before the 1880s. In 1883, construction began on the north side of the common to build St. John's Church. It served the small parish until a larger church was needed, and in 1960, it was converted to Father Mealey Hall. It now holds church functions and activities, situated conveniently to the new St. John's Church.

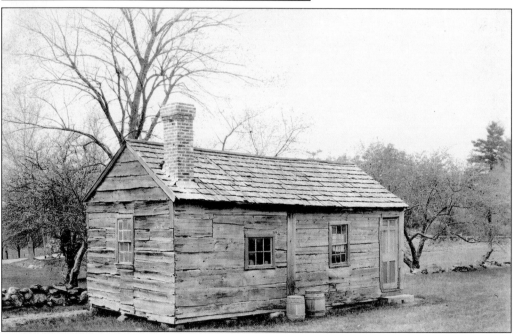

Coopering would become Townsend's major industry, developing largely in the town's center. The trade had humble beginnings, however, in small farmers' sheds and unpretentious buildings, such as the one in this photograph. The Fessenden family owned the building, but there were so many like it in town, the photograph is labeled simply "an old cooper shop."

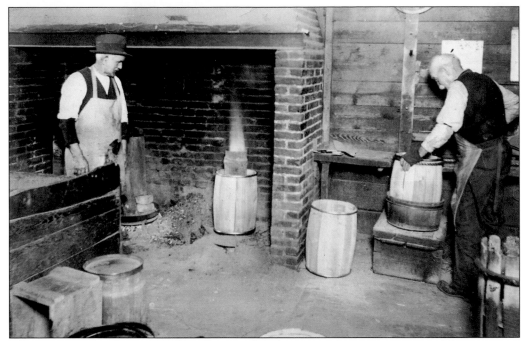

This interior view of a cooper's shop illustrates hand coopering, a time-consuming, labor-intensive job. A good cooper might take three weeks to turn a pine tree into a finished barrel. Working amid the piled hoops, cooper's fireplace, and unfinished barrels are coopers John Morse (left) and Melvin Davis.

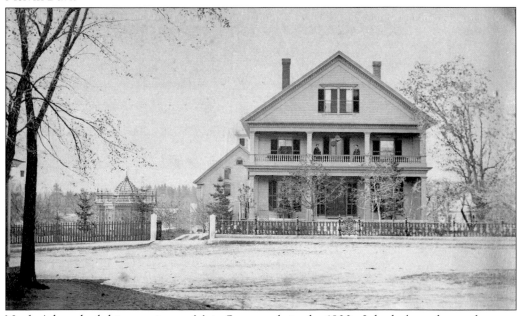

Noah Adams built his mansion on Main Street early in the 1800s. It had a barn, horse chestnut trees, and oval stepping-stones for visitors alighting from their carriages. Adams's grandson Union would later raise peacocks in the "peacock house," visible on the left. The Adams family was a wealthy manufacturing family in the center, owning a lumber mill and gristmill, in addition to a cooperage. The building now houses the Anderson Funeral Home.

The Wood Farm on Worcester Road was built in the 1700s. Capt. Isaac Kidder, one of Townsend's militiamen, lived there. His grandson Abram French, who owned the property in later years, established a morocco factory nearby (morocco was a fine leather made from goatskin, tanned with sumac). After French, the Wood family raised cows that produced enough milk for daily shipment to Boston.

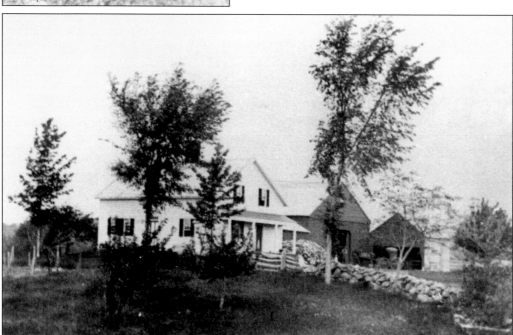

This photograph of Calvin Boutelle's homestead was taken around 1870 and shows the barn and carriage house on the right. Dating back to the 1700s, the farm was the birthplace of Thirza Boutelle, who would marry Anson Fessenden in 1864, as he rose to prominence in town. It is located at 16 Boutelle Road, off Meadow Road.

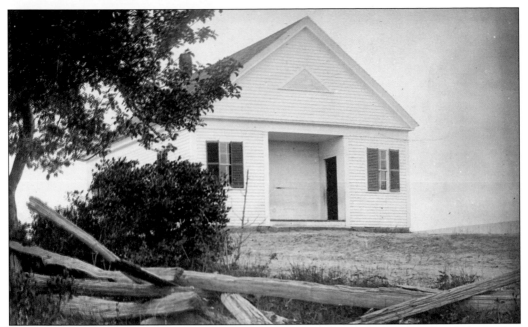

In the 19th century, Townsend was dotted with district schools that had replaced the earlier squadron schools. This one-room schoolhouse in the center was No. 12, built on Brookline Road around 1844. It is fairly representative of the district schools used by children in town until the early 20th century.

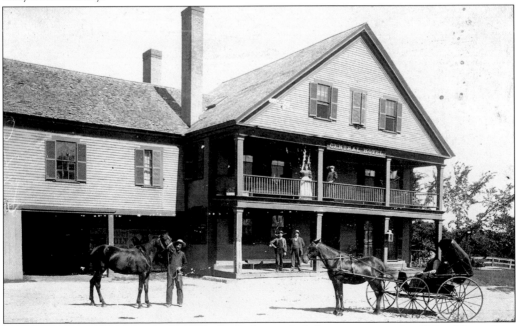

Moses Warren built the Central Hotel after he learned of plans to create a third New Hampshire turnpike from Townsend Center to Walpole, New Hampshire. Already the owner of West Townsend's Hobart Tavern, Warren proved himself a shrewd businessman, since he captured much of the stagecoach traffic through Townsend in the early 1800s. During the 20th century, the hotel, located on Turnpike Road, fell into disuse and was torn down in 1959.

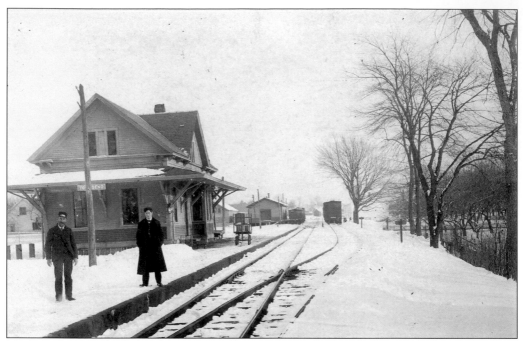

Townsend Center had already supplanted Townsend Harbor as the commercial and industrial base of town when the railroad opened in 1846. The center truly thrived once trains connected it to the other two villages and the larger world. This late-19th-century photograph of the Townsend Center station shows uniformed railroad employees in the foreground, a baggage cart in front of the depot, and the freight house in the background.

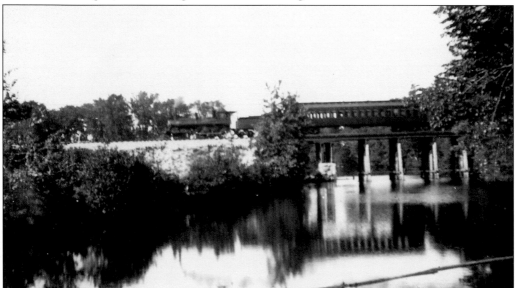

A train, pulled by an old steam-powered engine, crosses the railroad trestle near Townsend Center heading east. This unusual view was captured on film in the 1890s using glass plate photography. R. A. Lancey, inventor and engineer for the B. and A. D. Fessenden Company and Spaulding Fibre Company, took many glass plate photographs of Townsend scenes around 1900. The photographer of this image is unidentified, but it is possible that it was Lancey.

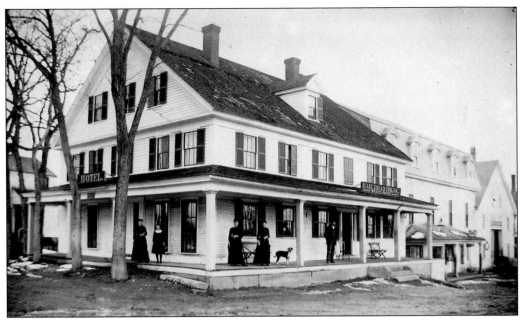

The Townsend Hotel was built in 1831 as a stagecoach stop on the Boston-to-Keene route. After the arrival of the railroad, the name changed to the Railroad House. Eventually it became the Park Hotel, growing to three grand stories that held 50 rooms. Fire destroyed the building that once sat so imposingly on the corner of Brookline and Main Streets. (Courtesy of Donald Keefe.)

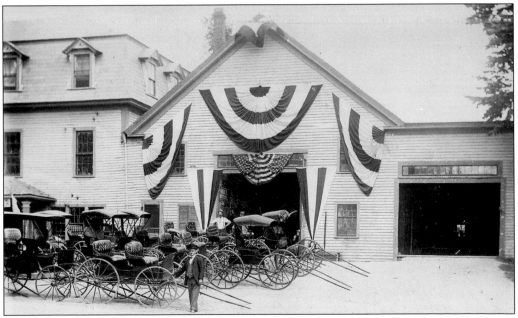

By the 1870s, the Park Hotel had an attached arcade with two small businesses and a livery stable that stretched along Main Street. At the time of this photograph, James Farrar, pictured, was owner of both the hotel and livery stable. Farrar was a colorful, if somewhat controversial personality, welcoming traveling salesmen to his hotel and supplementing his income by working as a local undertaker.

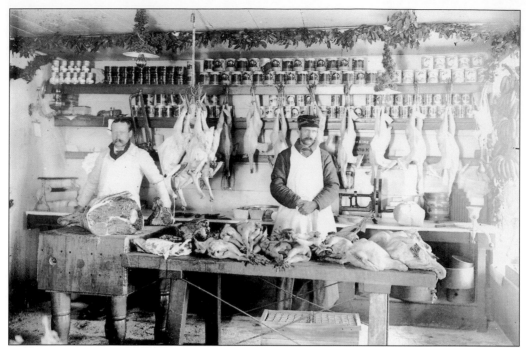

A meat market was housed in the arcade next to Frank Weston's harness shop. Although the market changed hands periodically, Charles Daniels (left) and Will Reed were the owners at the time this photograph was taken.

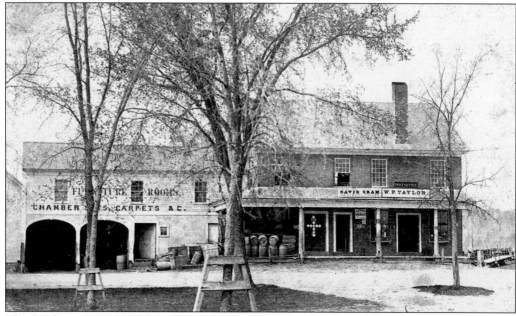

The brick store at 260 Main Street in Townsend Center dates from 1809. Built by Samuel Stone, a successful local merchant, the store has been owned by many proprietors. At least two merchants provided palm leaf to local women, exchanging goods for finished hats. This photograph was taken in the 1860s, before owner William P. Taylor moved the extension on the left behind the store to make room for his stylish 1871 Victorian home.

Earnest and conservative, Taylor was a respected merchant, businessman, civil servant, and community leader throughout the second half of the 19th century. He was appointed postmaster during Lincoln's administration, operating the post office out of his general store during the difficult Civil War era. Taylor purchased the Railroad House mid-century and further expanded his business interests when he built a furniture factory in 1874, north of Townsend Center.

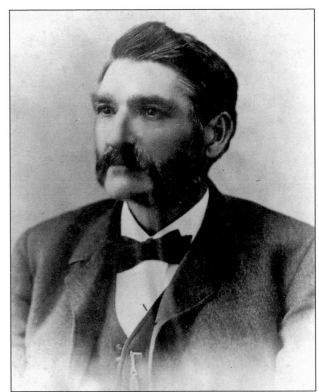

This photograph, taken around 1900, shows William Cowdrey (left) in front of his barbershop and Ellis Lawrence in front of his cobbler shop. Located on Main Street in Townsend Center, Cowdrey's tonsorial parlor enjoyed a large clientele throughout the early part of the 20th century. His son Rouy would later work beside him in the same trade.

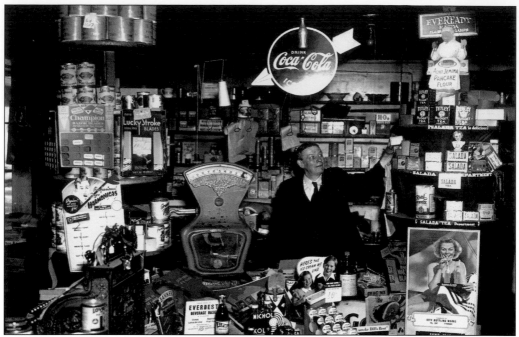

Samuel Woods poses amid merchandise at his general store in 1940. Cluttered with goods and advertisements, the store invited purchases and friendly conversation alike. Long before Woods, William P. Taylor's merchant rival Charles Osgood operated his store in the same building at 269 Main Street. When presidential parties shifted, Osgood served as the postmaster during the Democratic administration, sorting and dispensing mail in his store.

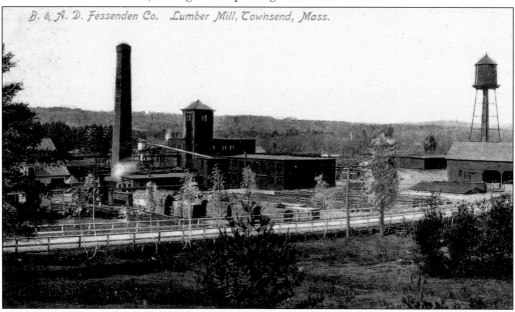

Coopering developed as a true industry in Townsend Center, especially after Anson Fessenden and his father, Benjamin, formed the B. and A. D. Fessenden Company. Their lumberyards, sawmills, and cooperage factory surpassed all others by the end of the 19th century, and the company grew to be Townsend's largest employer.

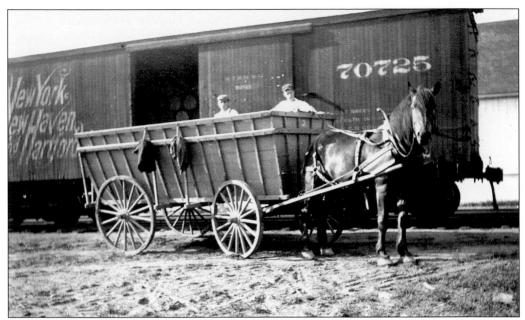

The Fessendens built their early operation in 1864 close to the railroad track in Townsend Center. Their focus was to enlarge the business by mechanizing the barrel-making process. The first day, father and son tripled production, making railroad transport essential. In this photograph, Fessenden barrels once neatly stacked on the horse-drawn wagon can be seen loaded inside the freight car. (Courtesy of Donald Keefe.)

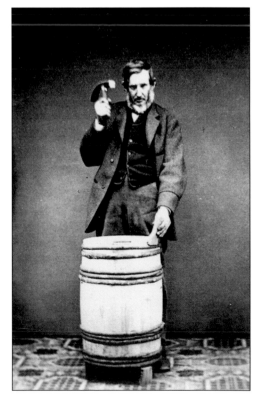

This marvelous photograph of Benjamin Fessenden, taken in the company's early years, may well have been a marketing effort. Fastidiously dressed in a business suit, Benjamin is posed with an adze, one of the tools used by the leather-aproned coopers who made barrels by hand.

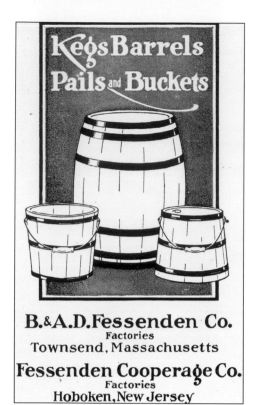

Keos Barrels
Pails and Buckets

B.&A.D.Fessenden Co.
Factories
Townsend, Massachusetts

Fessenden Cooperage Co.
Factories
Hoboken, New Jersey

A much-later advertisement promotes Fessenden Cooperage products. The company grew and expanded beyond Townsend and well into the 20th century, maintaining a focus on cutting-edge technology in barrel production. Fessenden Cooperage gained national recognition in the industry, and the factory operated in town until 1960.

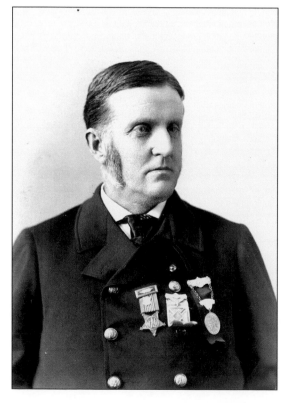

Anson Fessenden (1839–1907) was arguably the most influential individual in Townsend. Well educated and ambitious, he revolutionized the local coopering trade. His Civil War service in the 53rd Regiment, Company D, affected Fessenden deeply. He was fiercely loyal to his comrades, forming the Veterans' Memorial Association and spearheading efforts to build Memorial Hall in honor of local veterans, living and dead. He poses here at midlife. (Courtesy of Donald Keefe.)

Fessenden was not without self-interest, however. When Walter Fessenden's mill burned down, Anson agitated for a fire department, putting pressure on town officials as head of his own powerful company. The expense was controversial, but each village gained a fire station and equipment. Townsend Center built a fine brick engine house in 1875, named the Squanicook Steamer Company No. 1. It was staffed exclusively with volunteers.

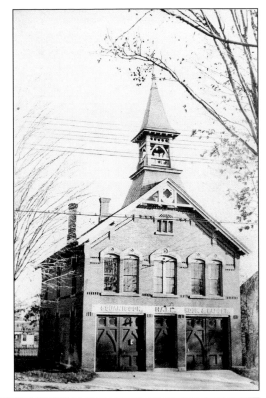

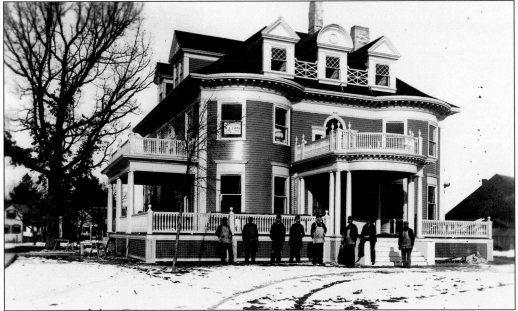

The Fessenden name became synonymous with business acumen, power, and wealth. Anson's cousin Albert was also a successful man, ultimately becoming bank president. He was planning a retirement house north of the common when he died unexpectedly. His widow, Anne, continued his plans and built the small mansion where the noon house once stood. It was completed in 1898 at a cost of $15,000 and is now known as St. John's Rectory.

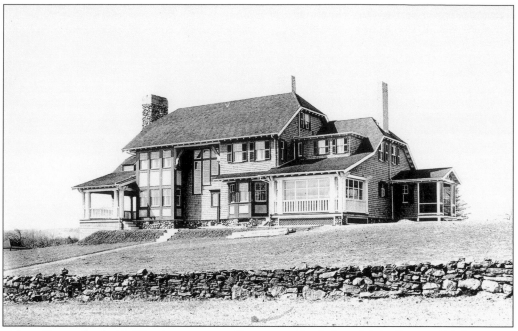

Robert Fessenden built Wyndecrest, a small estate set back from Main Street, slightly east of Townsend Center. He ran the Fessenden Company during its peak years in the 1920s. Robert and his wife, Helen, hosted countless social and charitable events at their estate. The land was bare of trees, and Wyndecrest was newly built when this photograph was taken.

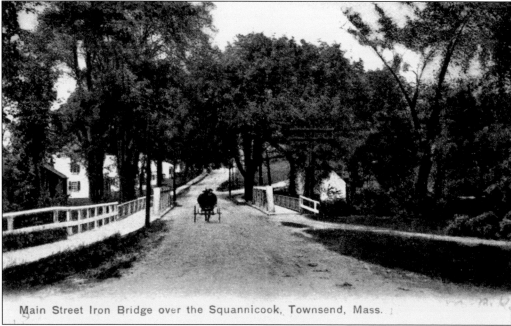

Main Street Iron Bridge over the Squannicook, Townsend, Mass.

The Squannicook River separates Townsend Center from West Townsend, requiring a bridge to span the divide. Suitable for horse and buggy, this narrow iron bridge of the 19th century survived into the 1950s, despite increased truck and automobile traffic. This photographic view faces westward, away from Townsend Center toward the village of West Townsend.

Three

WEST TOWNSEND

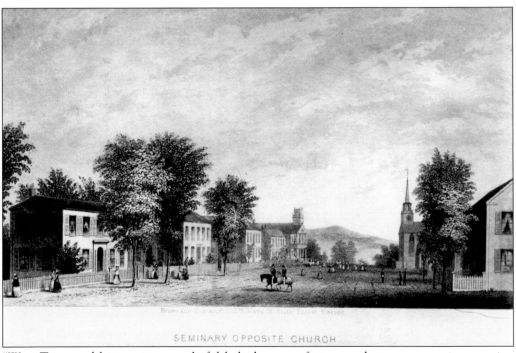

SEMINARY OPPOSITE CHURCH

"West Townsend history is a wonderful kaleidoscope of stagecoach taverns, granite quarries, female seminary, tub factories, tanneries, gristmills, old railroad depots, Friday night Lyceums, firemen's musters and just about everything else that goes to make up an active New England community," said local columnist Elsie Lowe in a 1965 lecture. This etching from the 1830s, printed in the seminary catalogs, shows the West Village Female Seminary and a view of Main Street looking west. This was an era when West Townsend was flourishing as a cultural and intellectual center. The Baptist church on the right was built in 1835. The seminary, built across the street the next year, promoted itself as "located in a very healthy region of the country, and remote from influences unfavorable to study." Although all the houses in the picture stand today, Main Street was never this wide and grand.

The Joslynville Tavern, possibly the oldest building in West Townsend, was built at the west end of Main Street in the third quarter of the 18th century. It was originally known as Stone's Tavern. The large barn housed horses and coaches on the stage route from Boston to Keene, New Hampshire. Joslynville, the westernmost section of West Townsend, was named for Samuel Joslyn, who ran the tavern before the Civil War.

The Joslynville Tavern has undergone many changes, including the addition of columns and a change of roofline in 1948. It has been used as an inn on the stagecoach line, a private club, an antique shop, and currently, a private residence. The ballroom on the second floor and many interior details remain from its early days.

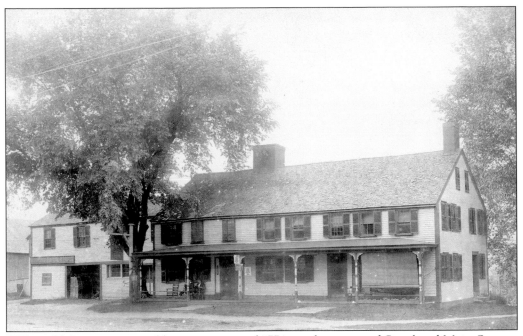

William Hobart constructed his tavern around 1774, on the corner of Canal and Main Streets. Moses Warren purchased the tavern in 1785, enlarging and improving it by adding a ballroom with a spring floor. It was the major stop for stagecoaches on the Boston-to-Keene route after 1805. The tavern has been variously called the West Townsend Hotel, West Townsend Tavern, Squannicook Inn, Ronchen Inn, and Hobart House.

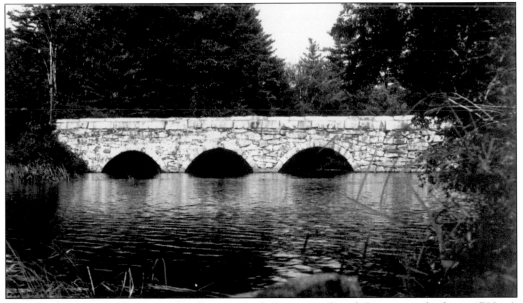

This lovely stone bridge over the Squannicook River on Canal Street was built in 1792. A canal, dug in 1798, created an island that was the site of various mills and factories, including a sawmill, gristmill, cotton-yarn factory, stocking factory, machine shop, and wheelwright mill. The Spaulding brothers, who ran the large leatherboard factory in Townsend Harbor, operated a second one here as well.

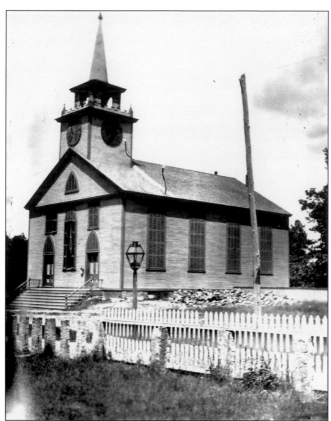

West Townsend's Baptist church was built on Main Street in 1835 by Josiah Sawtelle. Levi Warren donated the land and almost one-third of the money needed to build it. His brother, Moses Warren Jr., gave the bell, and a nephew, Charles Warren, gave the clock in the tower. The church looks much the same today, except that the steps across the front are now constructed of cement rather than wood.

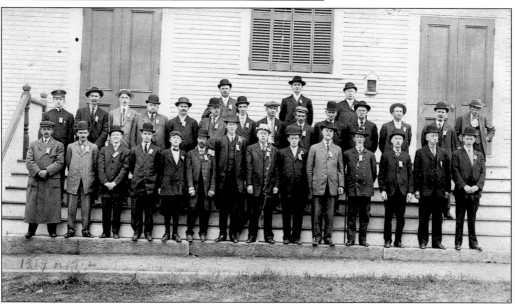

The Baptist Church organized a men's social group in 1912, called the Brotherhood. Many of West Townsend's prominent men were members. Fifty strong at the height of membership, most of these men were non-churchgoers. Standing on the front steps of the Baptist church, they proudly display their pins and ribbons.

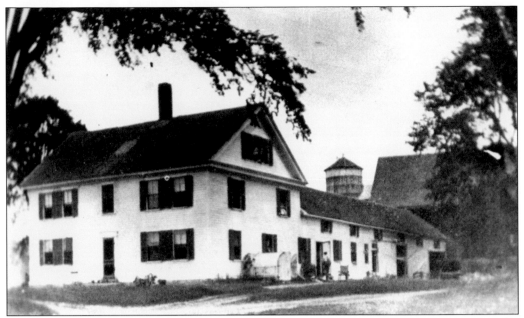

In 1834, the town purchased the c. 1800 Sherwin Tavern at the corner of Mason and Greenville Roads to use as an almshouse, or poor farm, for the poor and indigent. Intended to prove self-supporting, the Townsend Poor Farm, governed by a board of overseers, housed the town's paupers. After 1900, the building served more as a town infirmary for the elderly. The town sold the 15-room building in 1950. (Courtesy of Gary Shepherd.)

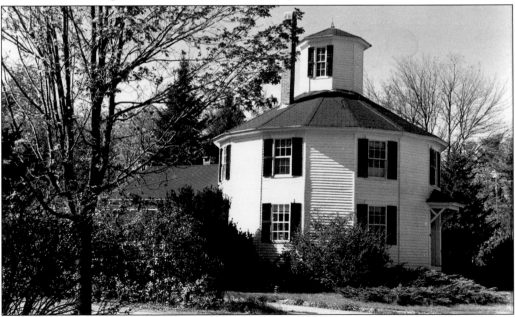

Townsend has two octagonal houses, the products of a late-Victorian architectural fad. A 16-sided brick house is in Townsend Center, and this 16-sided clapboard house is in West Townsend. Orson Squire Fowler promoted the round house as "comfortable to live in, easy to heat, and will fit on a small lot." Pie-shaped rooms radiate out from a central core. Journalist Elsie Lowe lived in this house from 1948 to 1992.

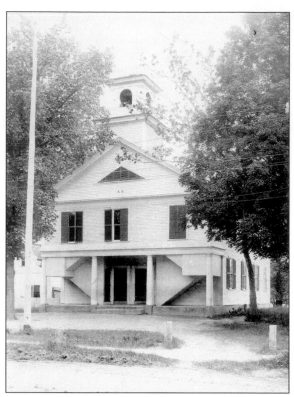

Seminary Hall was the main building of the West Village Female Seminary, which opened in 1836. There were also elaborate grounds with gardens extending down to the river. Considered one of the era's finest schools for well-born young ladies, the seminary educated about 70 girls at a time. The girls boarded with local families for under $2.50 a week, with washing, fuel, and lights included. Financial difficulties forced the school to close after 25 years.

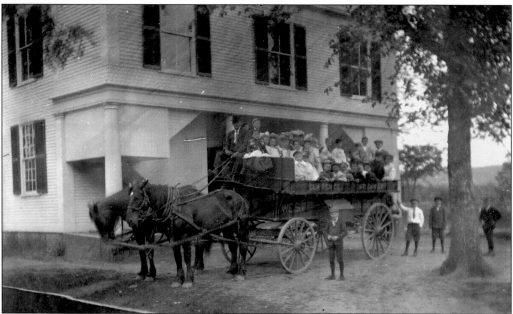

Clarence Stickney's horse-drawn "barge" transported schoolchildren to the former female seminary after it was refitted as a public school. This picture shows separate stairs for boys and girls, added when the town bought the building in 1870. Seminary Hall, also the home of the Friday night lyceums featuring debates, plays, and charades in the early 1900s, is now owned by the American Legion.

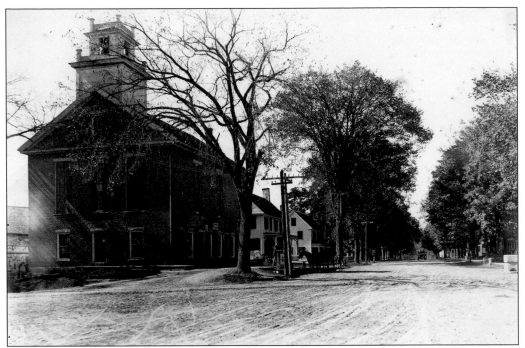

On the corner of Elm and Main Streets sits the Universalist building, built in 1849. The Univeralist Restoration Society, consisting of about 40 families, met in a large hall on the second floor until about 1865. Later the Temperance Society met on Monday nights in the hall. Captured in the photograph is the early transition between horse and buggy (at the store) and the early automobile (coming down Main Street).

The first floor of the Universalist building has always been a commercial space. When the building opened, Albert Howe ran a store there. At the time of this picture, the store was run by C. L. Webster and a gas pump stood by the street. Residents past and present have known this as "the old brick store." The building's steeple with its bell was removed in 1920.

Martha French Homer, Abram French's daughter, was born in Townsend Center. She met her husband, Charles Homer (artist Winslow Homer's older brother), at a dance in Cambridge, and they married in 1866. The couple lived an aristocratic life divided between West Townsend, New York, and Prout's Neck, Maine. "Mattie" was very generous to the children of West Townsend, giving them 25¢ for fireworks on Independence Day and gifts at Christmas.

The West Townsend Reading Room stands on the north side of the Squannicook River on Canal Street. In 1910, benefactress Martha Homer remodeled a small house into a reading room, paying to have books delivered from the town library in Townsend Center and distributed in West Townsend. By the 1930s, West Townsend was less isolated, and the new Hart Memorial Library had been established, so the West Townsend Reading Room closed. A town property, it is now rented for social functions.

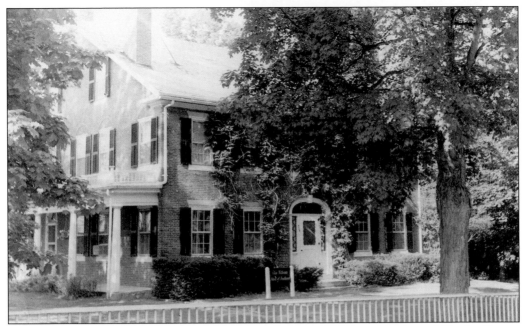

Aaron Warren built this large brick house for his son Ralph in 1823. Later Martha and Charles Homer made this home the social center of West Townsend. In the spring and fall, their horses would arrive by train with their English driver so that Martha could travel in style. Entrepreneur Elsa Williams bought the house in 1971, restored it, and opened the Elsa Williams School of Needlework.

Williams, born in 1912, was a talented needle artist and keen businesswoman. She bought the brick house at 445 Main Street, the former Homer House, and the Ronchen Inn, to establish Needlecraft House, the Williams Manufacturing Company, and the Elsa Williams School of Needlework. Local women were employed to produce needlepoint and crewel kits for her nationwide wholesale, mail order, and local retail businesses. (Courtesy of Jane Stonefield.)

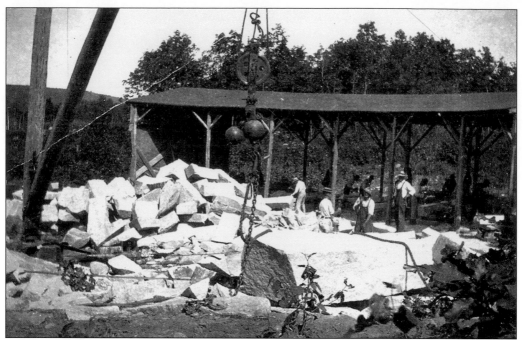

These men are working on a large granite slab in the stone shed at Rusk Quarry around 1916. The derricks and cables moved the stones from the quarry to the shed and then to the railroad siding. The quarry supplied its pink granite for the Worcester Post Office, Rockefeller Church, and Hammond Castle in Gloucester. The last stones were removed in 1936.

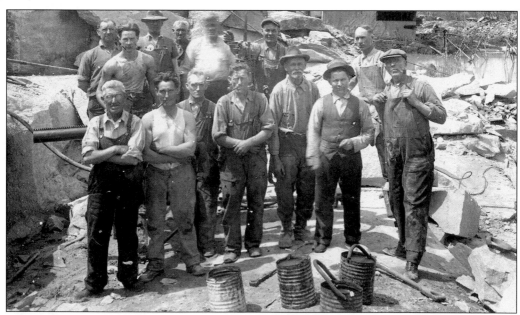

Duncan Rusk's granite quarry on Barker Hill started operating in 1900. It was the largest and most successful of West Townsend's several quarries, employing up to 200 men, 100 of them stonecutters. The work was both strenuous and dangerous, but Rusk was considered a good employer. Many of the quarrymen lived in a notorious boardinghouse on Dudley Road near the cemetery.

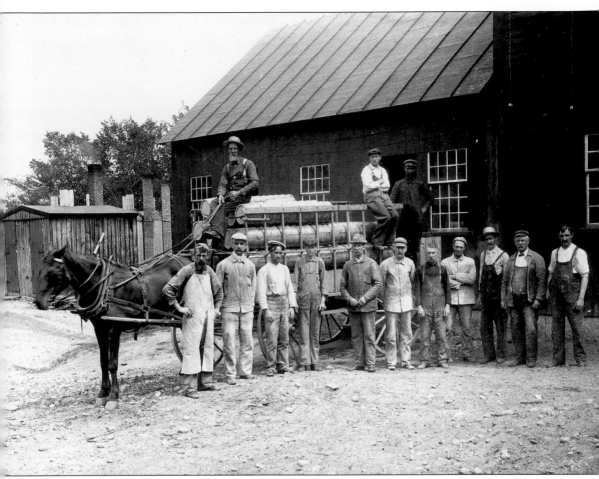

These workers, standing in front of a wagon full of completed tubs, represent the total workforce at Seaver's Tub and Pail Shop. Powered by both water and steam, the factory was said to have "first-class machinery." In 1890, E. W. Seaver and Company produced about $30,000 worth of goods. The building itself had a history common to many 19th-century manufacturing enterprises. It was built in 1849 on Main Street in Josylnville and was occupied by a number of manufacturing owners. One was A. M. White, who also built and made washing machines that looked suspiciously like barrels. Frank Ormsby, of Boston, bought the building in 1907 to produce hand-loomed carpets. Named the Belgrade Rug Company, the factory operated until 1932. After two more owners, the old building suffered an explosion in 1944 and burned to the ground.

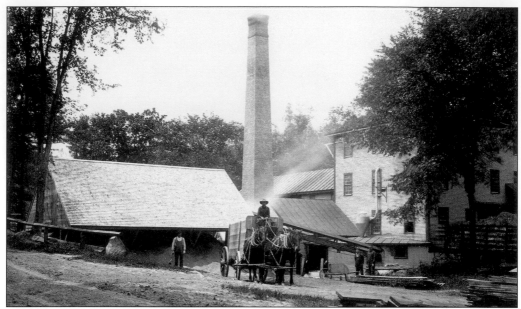

Clarence Stickney's mill was the last of several mills on this site on Wheeler Road at Willard Brook. A number of dams and ponds had provided power for this and earlier mills, including a gristmill, tannery, and sawmill. The Stevens brothers, George, Fred, and Augustus, had also operated a mill on the site, installing one of the water wheels they patented. Stickney's Mill produced lumber for the manufacture of barrels, packing boxes, and egg cases.

Stickney's mill was destroyed by fire in 1908, and only the chimney survived. It was moved down Main Street to the Damon and Richardson Mill, located approximately on the site of the current water department office. This was a great engineering feat, accomplished with rollers and oxen. These men, dressed in their suits for the photographer, seem justifiably proud of their accomplishment. This chimney was still standing in 1965.

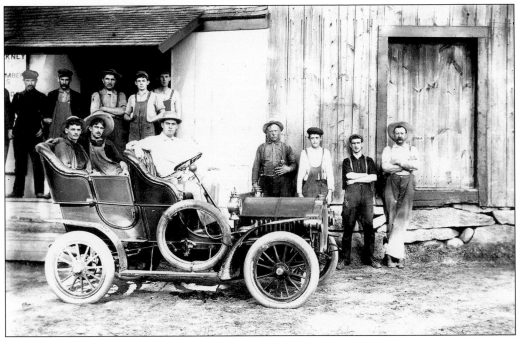

The men in this photograph were employees of the Stickney Lumber Mill. Although the men are unidentified and the image undated, the presence of the automobile indicates the photograph was taken not long before the mill burned in 1908. Stickney's Mill was one of Townsend's larger factories at the end of the 19th century.

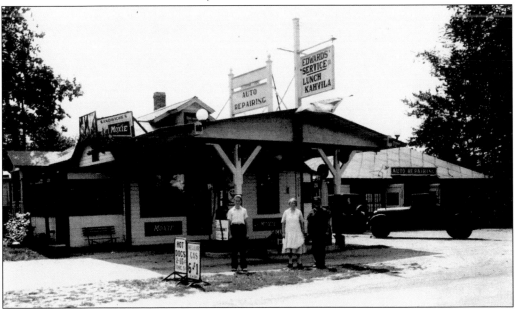

Here John Raymond Edwards and his parents, John Edward Kartalainen and Rosa Maria Lahtinen Kartalainen, are shown in front their business on Main Street across from the VFW pond. They represent many Finnish citizens who immigrated to the area in the early 1900s, attracted to the forests and fields that were similar to Finland's. They became successful farmers and small businessmen using *sisu* (enduring energy). (Courtesy of Emily Roiko.)

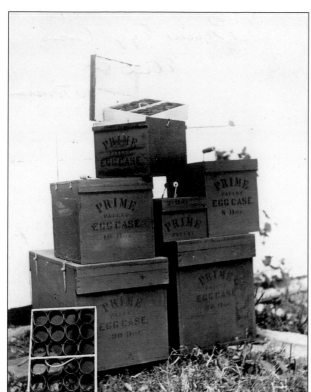

Prime egg cases were manufactured by Clarence Stickney on West Elm Street, located just above Aro's chicken farm. In 1895, 49 dozen complete wooden egg cases cost just $1.55. Except for Amadon's Brookside Farm on Wheeler Road, still in operation, the poultry business had disappeared in Townsend by the 1970s.

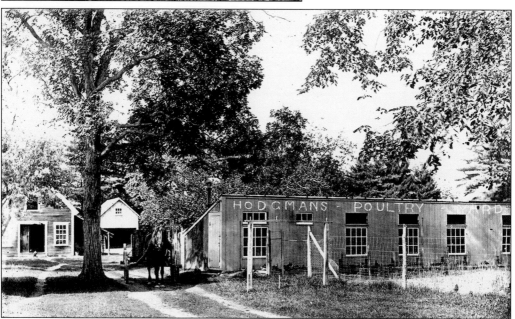

Hodgmans Poultry Yard on Main Street, opposite the Settle Shop Annex, was one of many small producers. The poultry business was a major agricultural enterprise in Townsend from the 1890s to the 1960s. George Aro on West Elm Street and Leo Makela on Bayberry Hill were large producers, feeding 30,000 or more chickens in large, multistory chicken coops. They supplied a major part of the New England egg market.

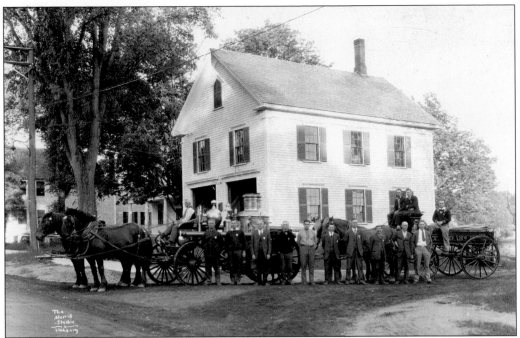

This photograph shows the West Townsend Eclipse Fire Company in 1928 at the corner of Main Street and New Fitchburg Road. Featuring "two-horse draws" in front of the station, the image was taken just before the steamer was replaced by Wachusett Engine 2. The engine house, built in 1875, is still in use.

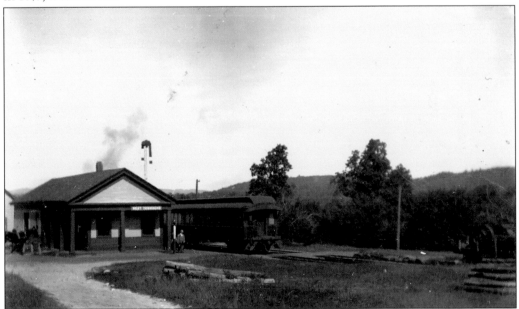

The West Townsend Depot, photographed during the glass-plate negative era, sits off Main Street at the site of Patten's Garage. The first rail line was built from Ayer to West Townsend and then extended through Mason to Greenville, New Hampshire. In the early 1900s, there were three trains a day in each direction, transporting blueberries, mayflowers, granite, and other goods. By 1950, there were only three freight trains a week.

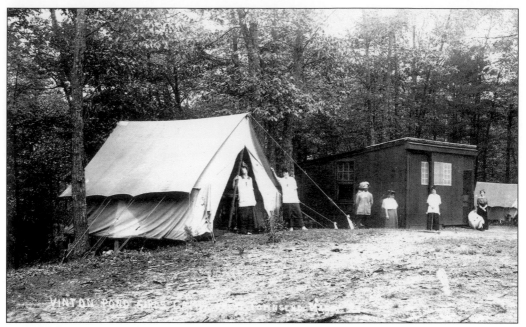

From 1896 until 1965, the Faith and Hope Association ran the Vinton Pond Girls Camp for young, working women "from the offices, department stores and factories of Boston." During the 1933 season, 450 women enjoyed a two-week vacation at the camp. In 1965, the Girl Scouts of America organization purchased the camp, renaming it Camp Kirby. Girl Scouts from Boston enjoyed Camp Kirby until it closed in 1972.

Beautiful Vinton Pond is bordered on two sides by Pearl Hill State Park. The pond is actually a kettle hole with no outlet. Several small cottages on the north side were originally built by Finnish workers from Fitchburg as summer retreats. Local historian and author Emily Lehtinen Roiko, whose parents built one of the early cottages, wrote invaluable histories of Vinton Pond and the Finnish residents of Townsend.

Four

ONE TOWN

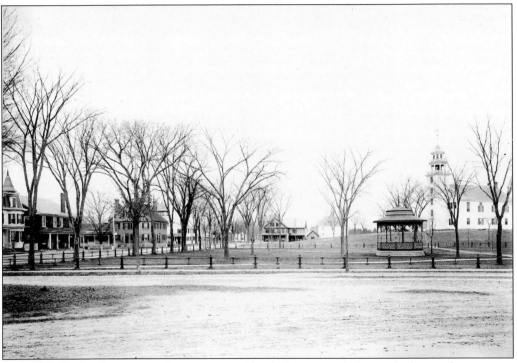

Early New England towns usually appropriated land adjacent to their meetinghouses for common use by the townspeople. This practice produced the term "town common." When Townsend's meetinghouse was relocated in 1804 to the town's center, the townspeople purchased the nearby land, then leveled and graded it. Herds of cattle driven along the old turnpike to southern New Hampshire pastured overnight on the common. The Townsend Light Infantry is believed to have mustered and drilled there, and its musical offspring, the Townsend Military Band, practiced there. After the Civil War, residents raised money to beautify the common, adding an iron fence around its perimeter. The Methodist Church donated the land to the town in 1894, and one year later a new bandstand was constructed. The common land, or town common, still belongs to the townspeople—whether from Townsend Harbor, Townsend Center, or the West Village.

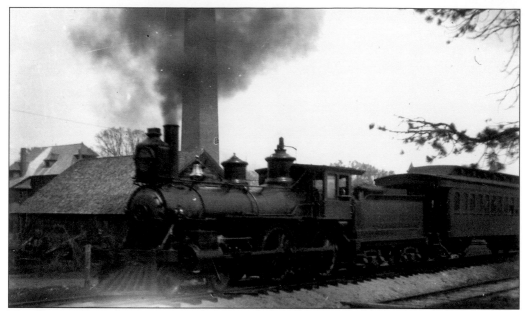

The three villages became more closely unified as a result of the Peterborough and Shirley Railroad, approved in 1846. The tracks, laid largely by Irish workers, connected all three villages. People could easily travel by train from one part of town to another and to towns beyond. Industries also benefited from improved product transport. Barrels, wood, leatherboard, granite, eggs, chickens, and ice were all shipped by rail.

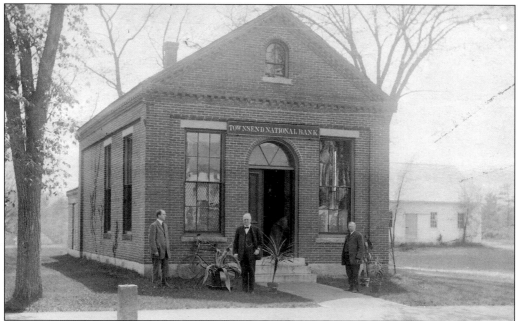

The Townsend Bank was chartered by the state legislature in 1854, becoming the Townsend National Bank in 1865. Walter Fessenden, one of its founders, was president from the bank's inception to 1884. This was Townsend's only bank until the 1980s, so it was patronized by townspeople from all three villages. The Union National Bank took over the Townsend National Bank in the late 1950s, closing its doors in 1982 when three other banks opened in town.

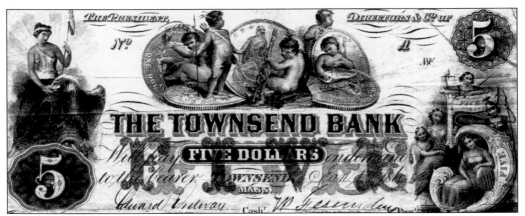

While the Townsend Bank was chartered by the state, it printed its own beautifully detailed bank notes. As the Townsend National Bank, the institution continued printing notes into the early 1920s, although the design changed. The old printing plates used to print the notes have survived to this day.

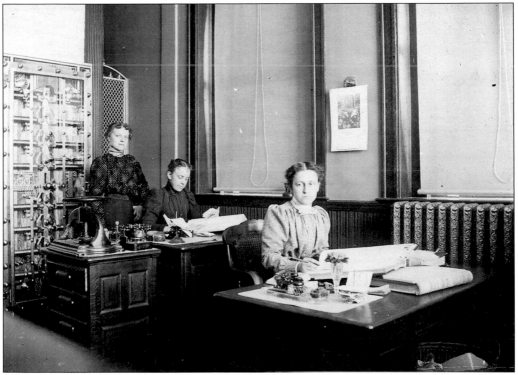

This photograph, taken about 1900, features the women employed by the bank. They are in the workroom, where the safe door can be seen in the back. By the late 1800s, women across the country were entering the workforce in large numbers, particularly in clerical capacities. Note the items on the desk.

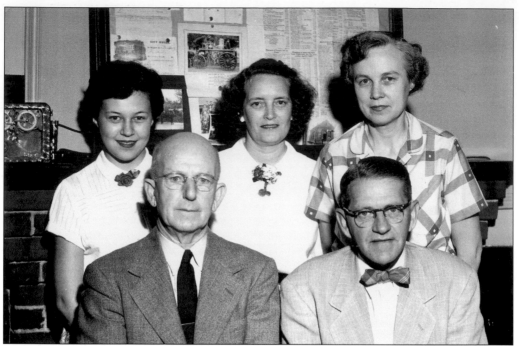

This picture of the bank staff was taken in 1954 when the bank was celebrating its 100th year of operation. A new addition to the bank building marked the anniversary. From left to right are as follows: (first row) Carl B. Willard, who worked at the bank for 62 years, and Cornelius P. Keefe, who worked there for 45 years; (second row) Joan Lemay, Mildred Smith, and Martha Ormsby.

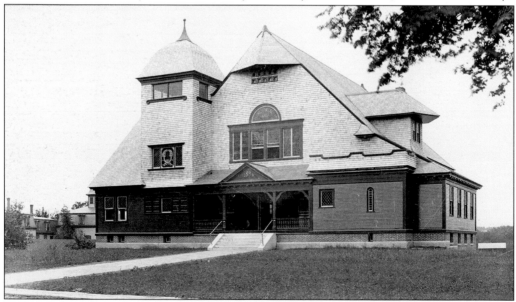

To honor his fellow Civil War veterans, Anson Fessenden raised funds for a new town hall, which was completed in 1894 at a cost of $16,800.77. Queen Anne in design, Memorial Hall was grand and spacious. A local wag called it "the Hall of Seventeen Gables," but the new facilities were above criticism. A banquet hall was on the lower level, and the building boasted a 600-seat auditorium, complete with a grand piano.

Memorial Hall was formally dedicated in July 1894. The Townsend Brass Band played throughout the day, and a noontime meal was served to 450 participants. Dedication ceremonies commenced at 2:30 p.m., culminating in a concert and ball in the new auditorium. Women carried a dance card (shown on right) listing the order of dances, which included the quadrille, waltz, polka, and schottische. Gentlemen could reserve a dance with his lady of choice.

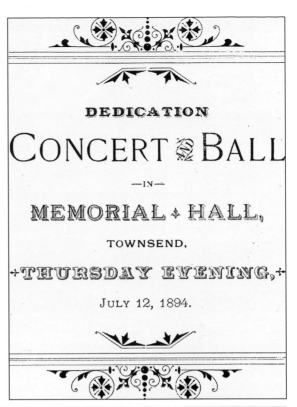

DEDICATION

CONCERT & BALL

—IN—

MEMORIAL ✦ HALL,

TOWNSEND,

✦THURSDAY EVENING,✦

JULY 12, 1894.

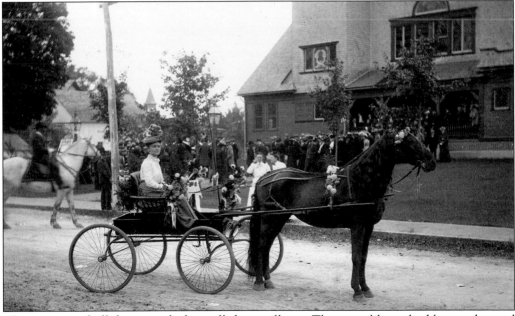

The new town hall drew people from all three villages. The town library had been relocated to the hall, and there were concerts, plays, lectures, dances, and dinners to attend. Memorial Hall became the focal point for town-wide celebrations. This unidentified woman, with her flower-bedecked horse, poses in front of the building at such an event. The presence of a utility pole (left) suggests the photograph dates from about 1900.

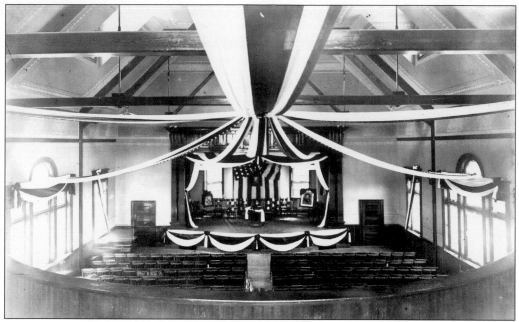

At Memorial Hall, residents could gather together to mourn national tragedies as a town united in shock and sorrow. The hall's stage and auditorium, draped with banners and bunting, were probably prepared to commemorate the assassination of Pres. William McKinley in 1901. President McKinley's portrait is on the stage.

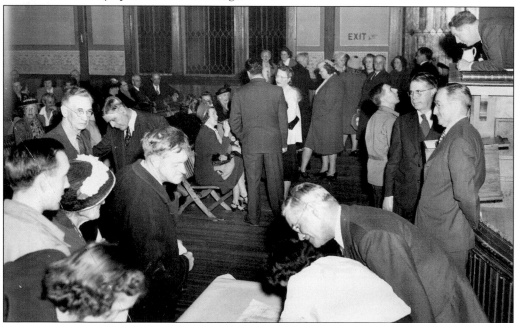

At the annual town meeting, townspeople are responsible for the decisions affecting town governance. Town meetings were held on the ground floor of the Methodist church until 1895, after which they took place in Memorial Hall until the 1950s. This photograph was taken in 1947, when Earle Bagley was moderator and Robert Copeland was town clerk. Town meetings returned to Memorial Hall after the massive renovations of 1999.

This cabinet, which remains in Memorial Hall, holds the weights and measures that were used by the town in the late 1800s. The town itself monitored weights and measures to protect local consumers. Tradesmen could expect to have their scales checked against these weights to ensure that all merchants used the same standards of measure.

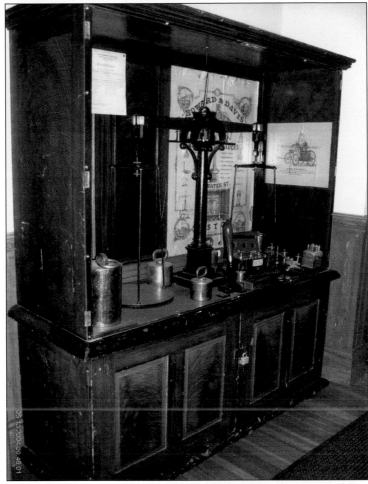

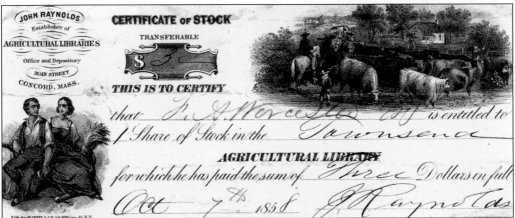

Subscription libraries preceded public libraries. In 1858, 100 citizens of Townsend gave three dollars each to start an agricultural library. A few years later, subscriptions gave way to a 50¢ tax imposed on those using the library, a policy that was dropped in 1882. Until 1894, the books were housed in various places: the meetinghouse, private homes, stores, inns, and even the fire station. In 1894, the books were moved to Memorial Hall.

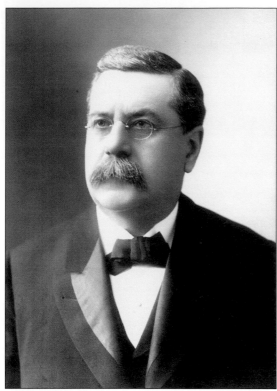

In 1923, Charles Hart, a local philanthropist, left $35,000 for a library to be known as the Hart Free Library Building. Amanda Dwight also left a bequest for the building of a library. Her disgruntled heirs filed a lawsuit contesting the will, stalling construction plans. Ultimately the building would be named after Hart, and the main reading room after Dwight's father, Walter Fessenden. (Courtesy of Townsend Public Library.)

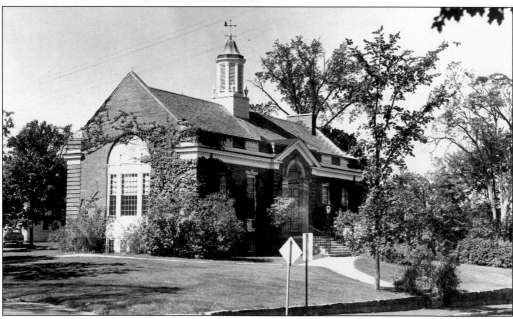

A hill overlooking Main Street, between the bank building and the Squannicook River, was the site selected for the new library. The dedication of the library took place in 1929, just as the economic conditions of the country plunged to a new low. The library immediately provided a source of affordable entertainment, enjoyment, and education for townspeople struggling through the Great Depression.

Evelyn Warren served as the town librarian for 50 years, from 1895 until 1945. She was dedicated to her work. Upon retiring, she received more than 300 letters, many from Townsend men and women in the service, and she was feted at a reception in Memorial Hall. Her final report was poignant: "I have loved our beautiful Library, working for it has blessed my life." (Courtesy of Townsend Public Library.)

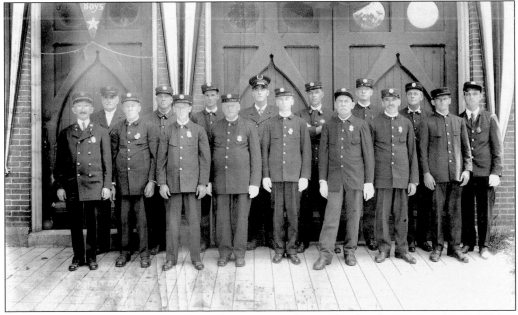

The town's fire department was formed in 1875 as the result of a devastating fire at Walter Fessenden's steam mill. A fire station was built in each village, and volunteers formed the three companies of firefighters. Until 1970, Townsend Harbor, Townsend Center, and West Townsend each had different uniforms. The men in this photograph made up the on-call fire department for the town in 1919.

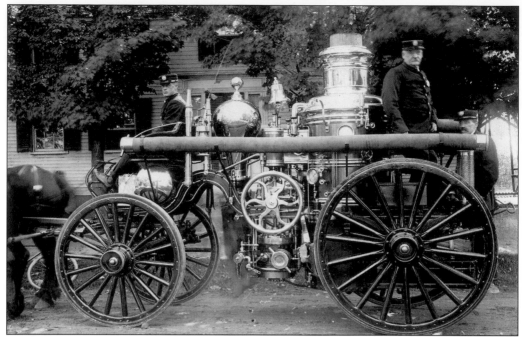

The town's first steam fire engine, an Amoskeag Steamer, was purchased in 1875. It was used until 1908, when the second steamer (pictured) was acquired. Henry Buckley is driving the steamer, while George Eastman sits at the rear. It was sold in 1908 and found again, in 1962, by Chief William Greenough, who brought it back to Townsend.

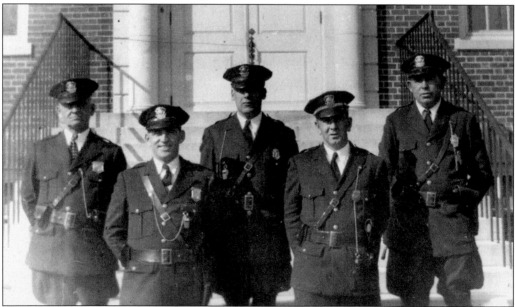

Townsend established its first police department in 1926. The department consisted of three officers who operated on a "call" basis. Prior to this, each village had elected constables to keep the peace. It was not until 1934 that the officers were provided with uniforms. This is a photograph of the police department of 1936. Pictured from left to right are Ira Carlton, Richard Keefe, Arthur Koykka, Howard Morse, and Howard Doran.

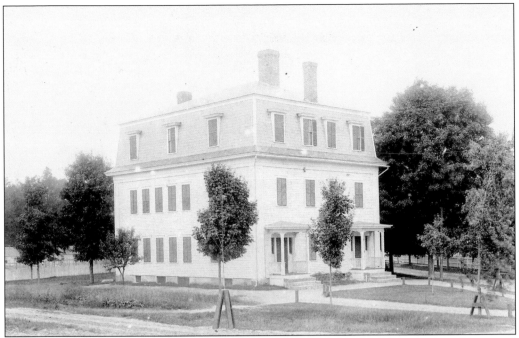

This three-story public school was built in the center of town in 1871, providing Townsend with its first high school. Qualified students from all three villages could attend. The building included rooms for the center's primary and intermediate grades. The high school was a three-year program until 1897, when a fourth year was added. The top floor was rented to the Independent Order of Odd Fellows and later to the Grange.

Early graduating high school classes were small. The graduating class of 1916 consisted of 11 students who posed in their most fashionable clothes. Shown here, from left to right are (first row) Isabelle Hayward, Helen Higgins Farrar, Amy Rixford, Natalie O'Brien Misner, Lu Arlin Goen, Esther Bagley Keefe, and Agnes Farrar; (second row) Harold Swicker, Fancis Struthers, Emerson Smith, and unidentified. (Courtesy of Donald Keefe.)

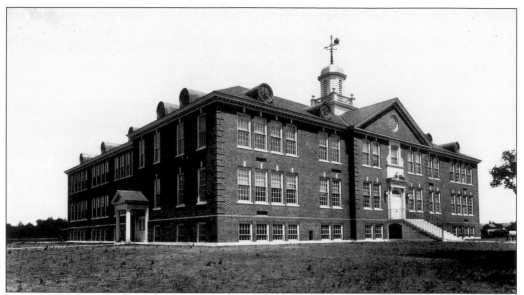

In 1930, Huntley and Rolland Spaulding offered to provide the town with a new, modern school building as a memorial to their parents, Jonas and Emeline Spaulding, longtime residents of Townsend Harbor. The Spaulding brothers grew up in Townsend, but later moved to New Hampshire, where each served as governor at different times. The final cost to the Spaulding brothers was $250,000 for the building and equipment.

In 1932, students from the three villages attended school in one central location for the first time. Spaulding Memorial School was built to house grades 1–12. Each room was equipped with a heat control instrument, telephone, ventilator, an attractive book closet, and bulletin boards made of cork. All Townsend students attended Spaulding Memorial School until North Middlesex Regional High School opened.

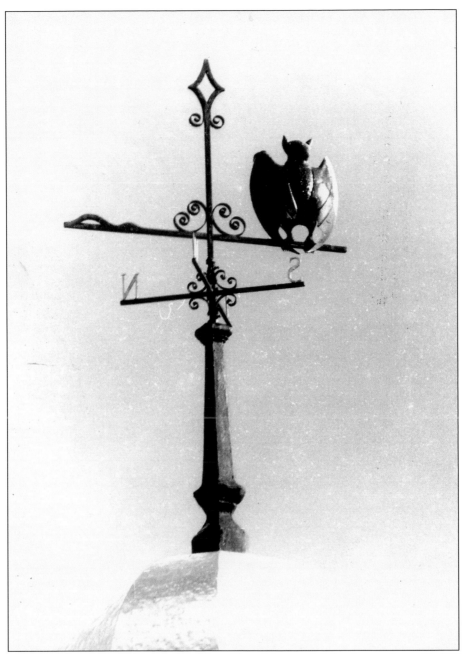

This bat, which has graced the cupola of Spaulding Memorial School since June 29, 1932, has inspired a great deal of speculation. The image of a bat for the weather vane seems like an odd choice; a wise, old owl is a more common choice. One theory states that the Spaulding brothers originally wanted to build a school twice as large as the final building. The townspeople refused, believing Townsend would never have enough school-aged children to fill it. The brothers acquiesced, but insisted that the bat be used as a weather vane to remind the townspeople that they had "bats in their belfry." Another theory maintains that an owl was ordered for the weather vane but a bat was mistakenly sent instead. It was installed temporarily, with the intent to return it. Seventy-five years later, the bat still sits on top of the Spaulding Memorial School.

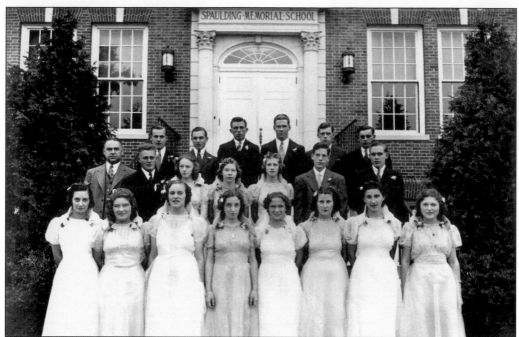

The 1939 graduating class stands on the front steps of Spaulding Memorial School. From left to right are (first row) Mildred Fleming, Nellie Immonen, Constance Rich, Charlotte Conner, Virginia Miller, Mary Milton, Lena Misner, and Carol Johnson; (second row) Principal Hamilton Bailey, Eugene Lampula, Margaret Grimes, Madeline Carleton, Sylvia Ely, Champney Benauer, and Toivo Wiiks; (third row) Eugene Mattila, Donald Weir, John Cook, Lauri Aijala, Richard Coffey, and Conray Wharff.

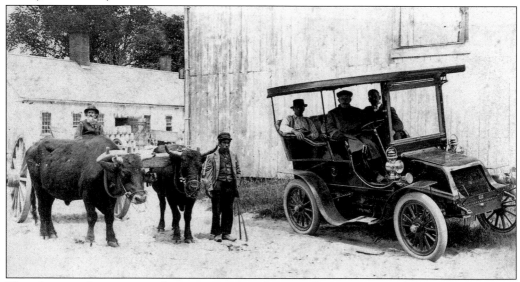

This photograph epitomizes the transition from horse and oxen to automobile. Gib Perkins and his son lead the team of oxen. Leon Spaulding (behind the wheel), Harry Whitcomb, and an unidentified man in back sit in the parked automobile. In 1986, Florence Sullivan remembered early drives: "It was the duty of the male guest to jump out [of the automobile] and hold the heads of the fractious horses we met."

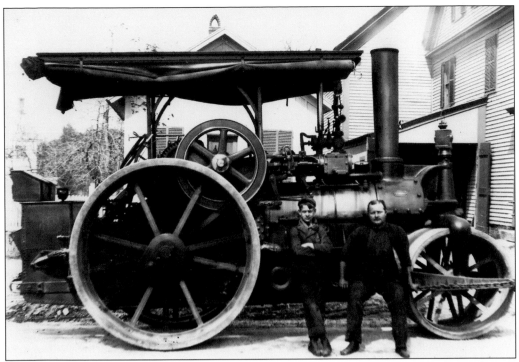

Automobiles provided the opportunity for improved travel between the villages and out of town, but most of Townsend's roads could not accommodate them. Rough, uneven dirt roads were common in rural areas. State officials determined the state road through Townsend should be paved; this steamroller did the work. The two unidentified gentlemen are taking a break beside Wood's Store (now the Duncan Matthews Bookstore). R. A. Lancey took the photograph.

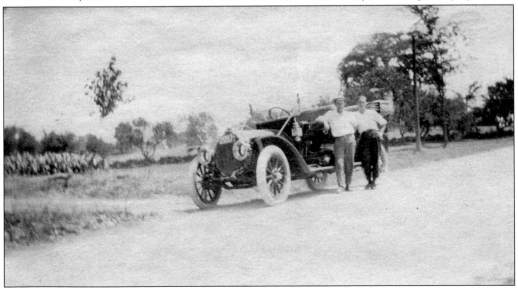

This wonderful 1911 Stevens-Duryea automobile belonged to Anne Fessenden, who lived in the mansion at the north end of Townsend Common. The two gentlemen standing beside it are Harry Winchester (left) and W. P. Taylor. Other early cars were owned by Dr. Atwood, Leon Spaulding, Roswell Lancey, and Robert Fessenden.

The Fessenden family garage first housed horses, and later, automobiles. By the time this photograph was taken, it had become a gas station. Early automobiles were used only in the warm weather as roads were not plowed, and there were no interior heaters. As automobiles became affordable, they gradually replaced horse-drawn vehicles.

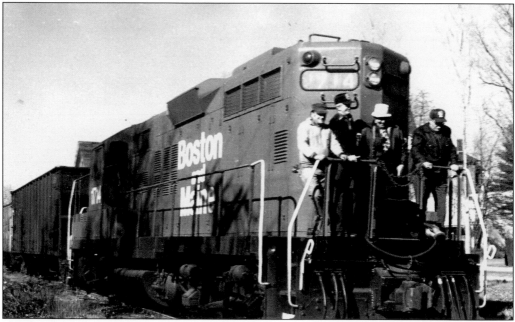

The last Boston and Maine train, a freight, left Townsend in 1981. At one time, six passenger trains a day served the town; all were discontinued by mid-century. It was the railroad that helped draw the three distinct villages more closely into one town, and with its passing, yet another era had ended.

Five

CELEBRATIONS

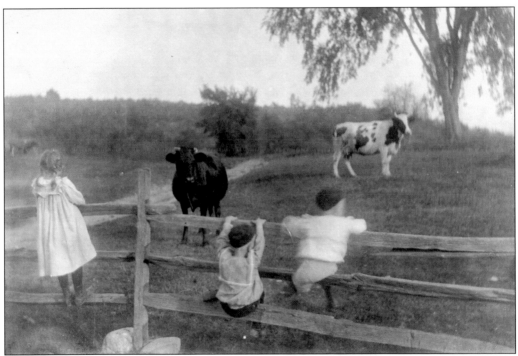

Celebrations in Townsend take many forms of expression, from raucous parties and grand parades to the quiet, simple pleasures of childhood and family life. Human nature requires the temporary release from the demands of everyday life that celebrations afford. Townsend holds many memories of annual events, such as the Firemen's Muster and Field Day, which were just plain fun. Sports like baseball and basketball entertained townspeople even through the Great Depression. Townsend residents filled their lives with those things that brought pleasure and joy: music, church events, bicycling, ice-skating, concerts, and balls. Even sorrowful losses could inspire solemn celebrations of commemoration. Children, of course, do not need a celebration to find joy. In this 1897 photograph, William O. Taylor's three children—Anna, Carroll, and William—are hanging on a fence to watch the cows in the pasture. A day trip to Groton or Ayer could provide the kind of simple pleasure that ultimately celebrated life.

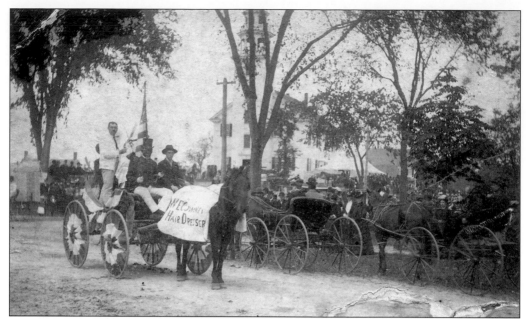

Parades have always been a popular way to celebrate any event. This late-19th-century photograph features a horse-drawn cart advertising "W. E. Cowdrey Hairdresser." Local businesses were not above using a parade entry for advertising purposes. The occasion for the parade is unknown, but Cowdrey has stopped in front of the busy town common, and the Methodist church is visible in the background, its yard crowded with revelers.

On September 24, 1902, the Townsend Grange sponsored a fair that featured a farmers' display on the common, a parade, band music, and other activities. The local chapter, which was established in 1892, boasted an inordinately large membership. Townsend Grange No. 194 was well known and respected for its public-spiritedness that produced so many town-wide improvements. Here the Grange's float rests in front of 7 Brookline Street, home of Dr. Atwood.

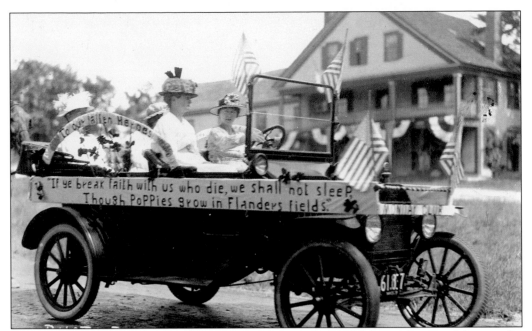

One of Townsend's largest parades was part of the town's 1919 Welcome Home celebration for returning World War I soldiers. Most town organizations sponsored a parade entry or float to express the widely felt relief and joy on the occasion. The Monday Club, which later merged with another organization to form the Woman's Club, used a popular poem written by John McCrae for their entry theme: "In Flanders Fields the poppies blow . . ."

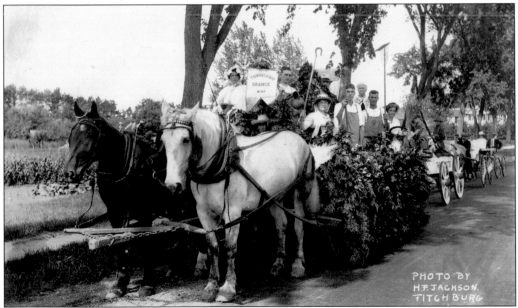

One of the finer floats in the parade was sponsored by Townsend Grange No. 194. With characteristic understatement, the Grange records made only a brief reference to the chapter's participation: "The Grange joined heartily with the townspeople in making this a grand success." In 1924, the Grange sponsored the gold star on Memorial Hall's lawn to memorialize the fallen soldiers from World War I.

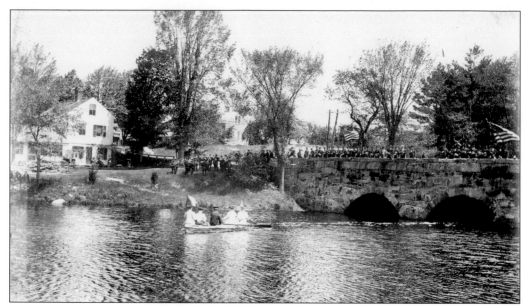

Memorial Day celebrations in Townsend have always been somber, reverent events. After the Civil War, the town honored their war dead on Decoration Day, which evolved into Memorial Day. Patriotic organizations marched to both cemeteries (West Townsend and Hillside), where children laid flowers on the veterans' graves. The women in this photograph, taken in West Townsend, are laying wreaths on the Squannicook's quiet waters in memory of deceased navy persons.

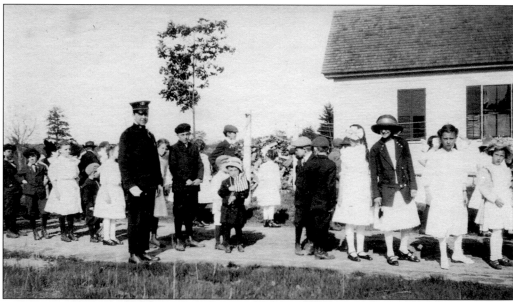

Townsend's schoolchildren provided their own Memorial Day programs. Dressed in their best clothes, the children, accompanied by a Townsend policeman, were marched from the Center School to the auditorium at Memorial Hall. Individuals, small groups, and entire classes would perform for a public audience. The programs must have seemed bittersweet to audiences, seeing youth juxtaposed against the aging veterans who had experienced the darkness of war. (Courtesy of Donald Keefe.)

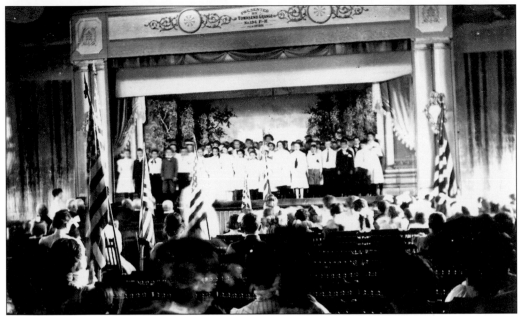

This photograph is undated, but the school Memorial Exercises for 1923 included patriotic songs from the traditional to the lesser known, such as "Low in the Ground They're Resting" and "E'er Fadeless Be Their Glory." Grades two and three performed a drama called *The Search for Happiness*, and grades four and five presented an entire pageant. Recitations included *In Flanders Fields*, Lincoln's *Gettysburg Address*, *Barbara Frietchie*, and *A Patriotic Child*.

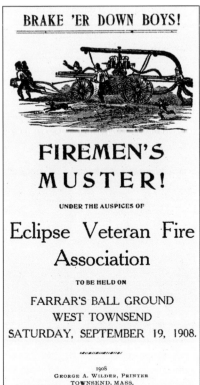

BRAKE 'ER DOWN BOYS!

FIREMEN'S MUSTER!

UNDER THE AUSPICES OF

Eclipse Veteran Fire Association

TO BE HELD ON

FARRAR'S BALL GROUND WEST TOWNSEND SATURDAY, SEPTEMBER 19, 1908.

1908
GEORGE A. WILDER, PRINTER
TOWNSEND, MASS.

Firemen's musters were highly popular annual events in Townsend. They were basically competitions between fire companies based on the longest stream of water the men could pump from their hand tubs. The addition of Field Day activities provided additional fun. This 1908 muster offers a decorated automobile parade, bicycle race, baseball game (Townsend Independents vs. West Townsend), and a tug-of-war—"West Townsend vs. all comers."

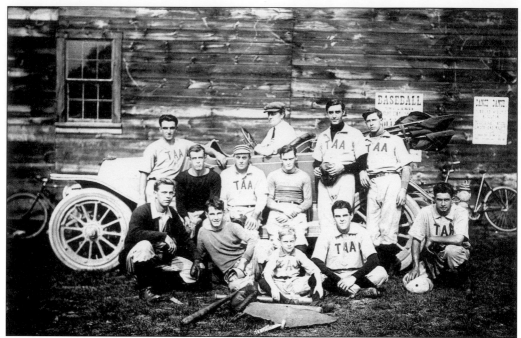

Robert Fessenden managed this 1910 Townsend baseball team. Many of the players worked at the mills in town. After long days of laboring, they headed straight to the ball field. Fessenden, one of the first in town to own an automobile, drove his players to away games. Here Fessenden is in the car. Other players are Harry Knight, Victor and Elwin Swicker, and Steve Keefe.

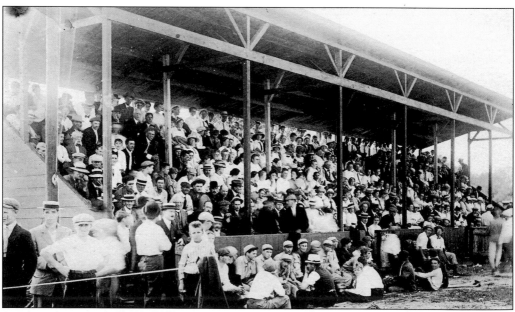

Sunday afternoon ball games drew quite a crowd to the Townsend grandstand. In this 1927 game, spectators watch and wait while the players, seated in front of the grandstand, plan their strategy. The grandstand was destroyed in a hurricane and later rebuilt as a smaller structure.

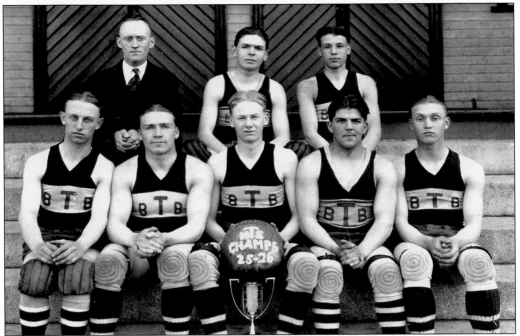

Basketball was a popular sport in Townsend during the early 20th century. The first games were played in the ballroom of the Park Hotel. Later games were played in Memorial Hall, with baskets hung over the stage and balcony. Players wore kneepads to protect against floor burns. The chandelier hanging from the ceiling was a hindrance. The 1925–1926 team poses here with its winner's trophy. (Courtesy of Memorial Hall.)

In addition to team sports, Townsend offered a less wholesome form of entertainment. South of the Squannicook River stood Riverside Park, complete with stables, sheds, and a racetrack. For a fee, spectators were admitted to the trotting park on Saturday afternoons to gamble. In April 1898, a fire ruined portions of the park and the rest fell into disrepair. Note the small sulkies, each with one horse and one driver. (Courtesy of Donald Keefe.)

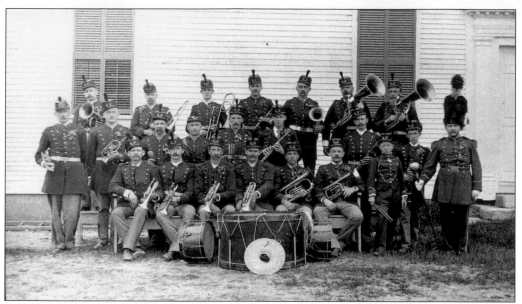

In 1888, the Townsend Cornet Band posed in front of the Center School. From left to right are (first row) John Dobson, Gerry Gilchrest, George Gates, Alvah Stickney, Maurice Levy, and Wallace Maynard; (second row) George E. Clark, George Streeter, Melvin Davis, Ellis Sanders, Bert Estes, Charlie Stickney, Jean Wetherbee, Newell Mitchell, George McGuire, and Jim Brogan; (third row) John Arlin, William O'Brien, Bill O'Brien, Clarence Stickney, Clarence Streeter, Charlie Cram, and Kendall Taylor.

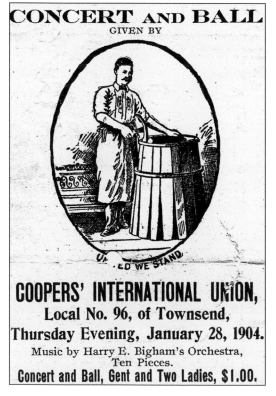

The Coopers' Concert and Ball was an eagerly awaited annual event in the early 1900s. Sponsored by the Coopers' International Union, the event began with a grand march of the town's elite and included a turkey supper. This advertisement was printed so it could be clipped out of the newspaper, with the full concert program printed on the reverse. Men invited a wife or girlfriend and his or her mother.

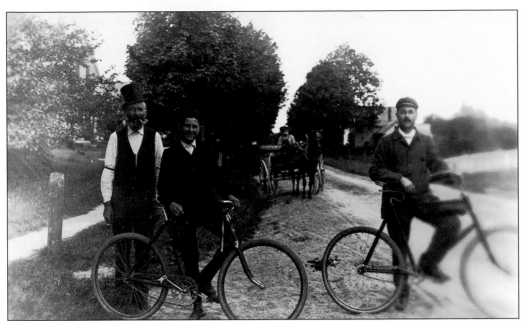

In the late 19th century, riding bicycles became a popular pastime. In this School Street scene, Will Cowdrey (right) and his son Rouy (middle) pose with Arthur Goldthwaite. In the background, George Lawton is transported by more traditional means. Local satirist Hale Gage wrote that "these wheels represent mortgages, unpaid grocery bills . . . last year's taxes behind . . . and the dash and spirit of the age. 'Twill be a long time before we say 'Bye, cycle.' "

Women also enjoyed riding bicycles. In fact, the activity may have been most popular with the ladies. It was the bicycle that changed women's fashion around the dawn of the 20th century. Women could wear shorter skirts paired with bloomers because the longer, fuller dresses often got caught in the pedals and spokes. Here Mrs. Clifton Patch, Abbie Cowdrey, and Betsey Clark show off their riding attire.

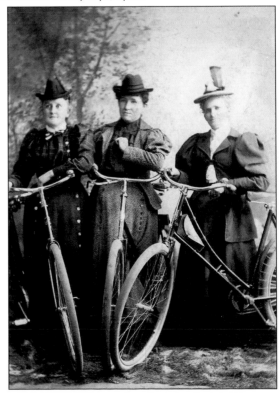

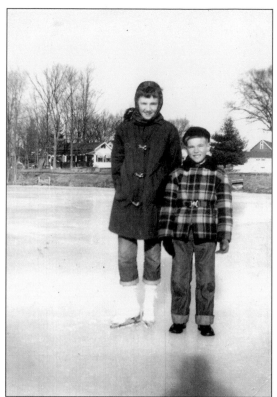

The Squannicook River has provided pleasure to every generation. William O. Taylor fondly remembered "the happy times I have had on [the Squannicook's] surface, in its depths, and on its banks" in his memoirs. Wintertime offers the opportunity for ice fishing and, of course, ice skating. Two children, Jane and Tim Pender, are shown practicing their ice-skating skills on the Harbor Pond in the 1950s. (Courtesy of Carol Wright.)

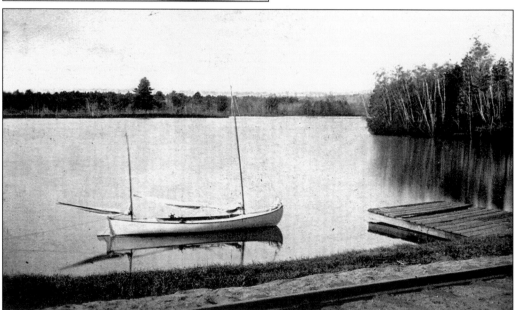

Warm-weather pleasures provided by the river are many. Each part of Townsend had its own swimming holes, including Harbor Pond, Black Rock, and the stone bridge in West Townsend. Fishing and the risky sport of "trestle jumping" are both still practiced. Boating has also been a favorite pastime, whether by canoe or rowboat. In this undated photograph, a sailing canoe rests on the calm waters of the Harbor Pond.

Important milestones in personal and family lives—engagements, marriages, and births—have always been cause for celebration. High school graduations were particularly significant, since so few students completed high school in the late 19th and early 20th centuries. Nellie Greeley was Townsend High School's salutatorian of the graduating class of 1905. In this formal graduation portrait, she poses in her elegant dress made of fabric especially brought back from the Philippines.

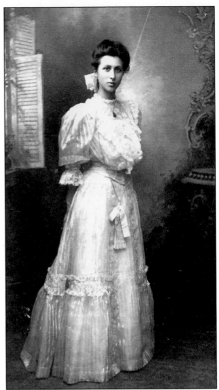

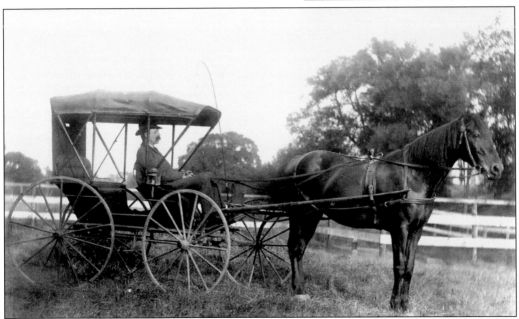

The photograph is labeled "Father in his Carry-all." William O. Taylor, like many townspeople, enjoyed taking his family on day trips in his horse and buggy. Taylor, born in 1858, had left Townsend for a career in railroading. He returned to town after his father's death, living in the family's 1871 house at 258 Main Street. Taylor's family often went to Ayer and Groton for day trips. Taken in 1897, this photograph also features Taylor's horse, Daisy.

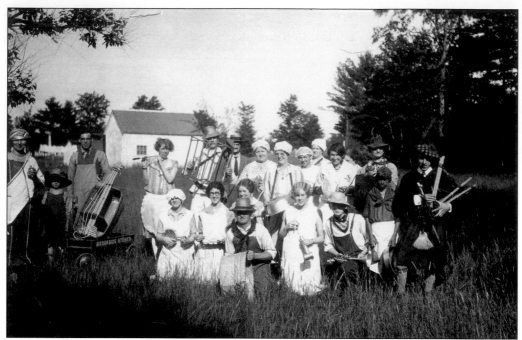

Some West Townsend residents formed the Old Kitchen Band, photographed in 1926. Neighborhoods often found their own reasons for celebration. No doubt finding common ground in their sense of fun and love of music, these musicians, with their makeshift instruments, must have created some joyous—if not melodious—concerts for anyone willing to listen. Some of the players' last names are familiar: Sherwin, Hodgman, and Rusk.

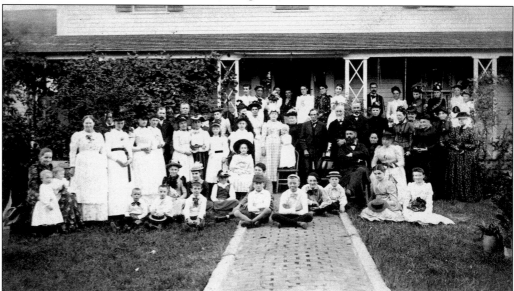

Churches provided important social outlets for townspeople. Adults and children alike attended this Congregational church picnic in August 1891. The event was held at a private home, the "Ebon Robinson place near Henry Miller's," according to the photograph labeling. Miller's house was on the Hart Memorial Library site, long before that building was constructed. An 1889 map shows Robinson's house across the street. (Courtesy of Donald Keefe.)

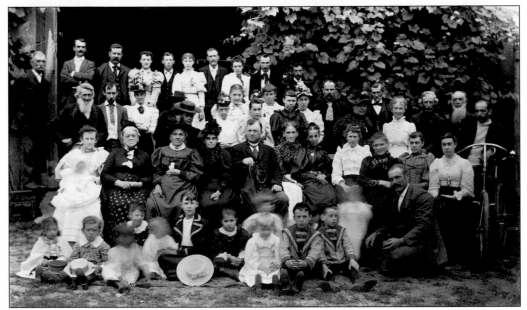

The Oliver Proctor farm on Warren Road in Townsend Harbor hosted many large gatherings, including an annual Fourth of July picnic. This photograph, taken by Charles F. Spaulding on July 4, 1895, shows more than 50 Caper Corner neighbors in attendance. Guests enjoyed a potluck meal followed by races, contests, and the annual pick-up baseball game between the married men and the single men.

"Childhood is life's playtime," wrote William O. Taylor. Children seem to celebrate life in much that they do. This unidentified little girl enjoys cuddling her cherished doll, but other childhood entertainments were far livelier. Taylor provided a list of them: run sheep run and snap-whip; impromptu baseball games on the common and the related barn tick game; hide-and-seek, spinning tops, and marbles played during spring's mud season.

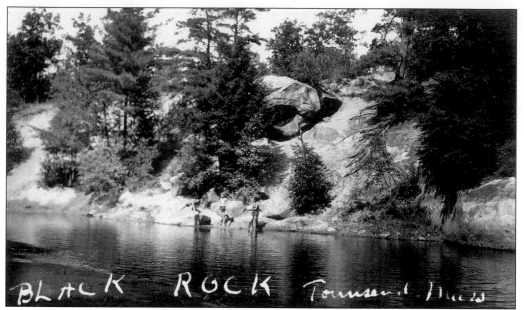

Local legends abound about Black Rock and the Native Americans passing through Townsend before the 18th century. According to one legend, the underside of Black Rock got its color from cooking fires built by the Native Americans. Legends aside, Black Rock has been a popular gathering place for generations of swimmers and picnickers.

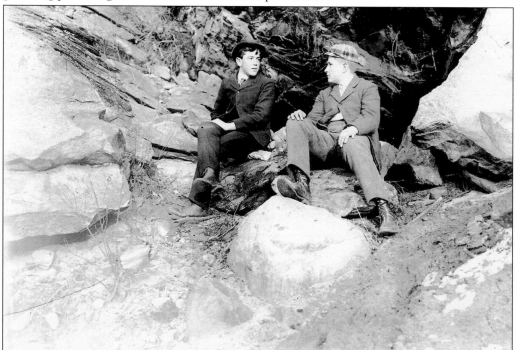

Two boys, Clarence Morse (left) and Rouy Cowdrey, sit at Black Rock in the early 20th century. Children of every generation have spent time there. After 1932, students at Spaulding Memorial School would walk down to the river, hang their clothes on nearby tree branches, and swim directly to Black Rock.

Six

ENDURING ADVERSITY

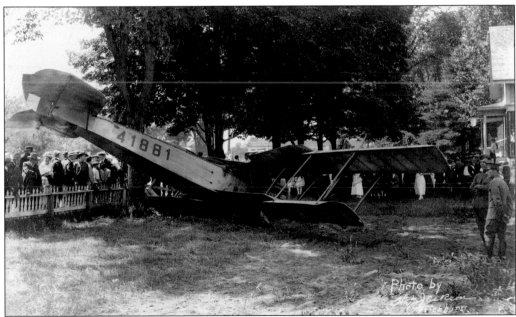

A plane crash marked the Welcome Home Celebration on July 25, 1919. Lieutenant Moffett was scheduled to fly over the festivities. The plane's engine died, and he crashed in the front yard of a house on Turnpike Road. He was unhurt. Townsend is a typical American small town, enduring adversity with strength and resolve. Townsend's men were sent first to establish the country in the Revolutionary War, some in Col. William Prescott's Groton company, later to preserve the Union, and through the years to defend the United States against many enemies. Natural disasters included a devastating forest fire in 1927 that destroyed much of Townsend's woodland, periodic flooding of the Squannicook River, and the hurricane of 1938. Economic woes included the demise of many industries, especially the closing, in 1960, of Fessenden's Companies, Inc.

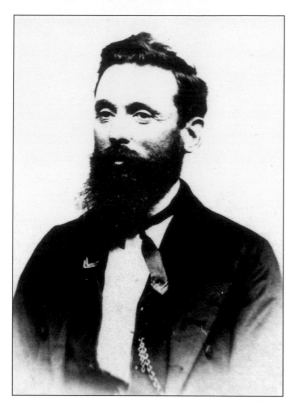

The Civil War sometimes pitted brother against brother, and even small northern towns like Townsend could have divisions in allegiances. Some local businessmen were suspected of being southern sympathizers, or "copperheads." Edwin Larkin, who owned a steam mill for producing barrel stock, fell prey to such suspicions. When his mill exploded in May 1862, killing and maiming several employees, many believed it was a vicious act of sabotage.

Alson S. Warren, Company D, 53rd Regiment of Massachusetts Volunteers, was 19 years old in 1863. Barely out of childhood, he died in Baton Rouge, Louisiana, far from home. He was only one of the roughly 270 Townsend men who served; he was only one of the 34 men who lost their lives. Like many Union soldiers, Warren succumbed to disease borne in the heat and humidity of the unfamiliar southern climate.

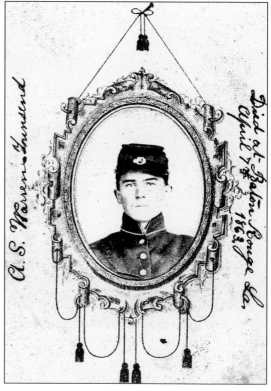

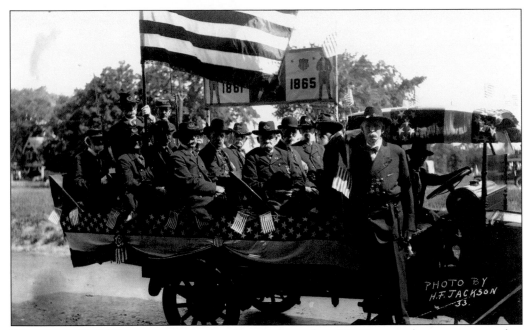

There were Civil War veterans who lived to see more than 100 Townsend men enter another war. World War I took place on European battlefields with advanced weaponry such as mustard gas. Eight men died, but the rest were joyously welcomed home in a town-wide celebration in July 1919. Some elderly members of the Grand Army of the Republic, 14 in number, joined in the parade to honor the new generation of war heroes.

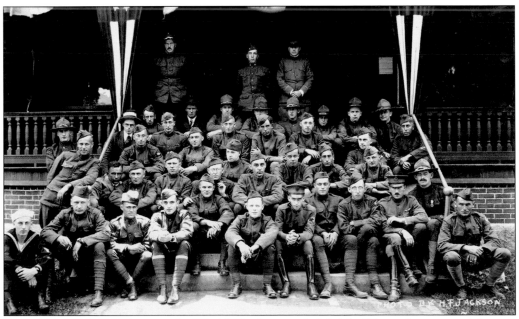

Every Townsend man who served in World War I received a Medal of Honor from a grateful town. The returned veterans pose as a group on the steps of Memorial Hall in 1919 at the Welcome Home Celebration held in their honor. A souvenir booklet produced for the day contained their names and service details.

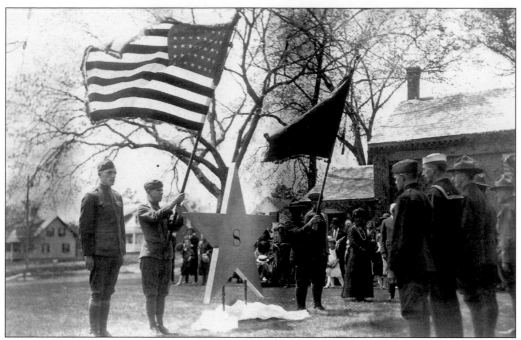

On Memorial Day, 1924, Townsend honored the eight Townsend men killed in World War 1 by placing a large gold star with an 8 on the lawn of Memorial Hall. The Townsend Grange sponsored the memorial. Nine Townsend men were killed in World War II.

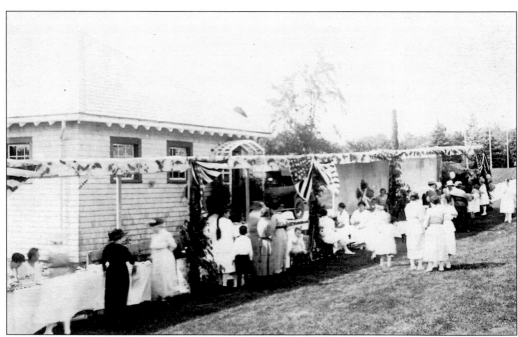

Helen Fessenden, wife of Robert, had a large lawn party in 1922 to raise money for the Red Cross. A total of 2,500 people came to Wyndecrest, their large green house at 170 Main Street. Events included a fish pond, ring toss, music, supper, and dancing on the tennis courts afterward. The Red Cross provided humanitarian aid to suffering people worldwide after World War I.

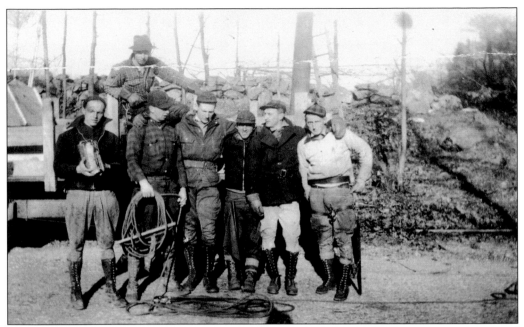

These Civilian Conservation Corps (CCC) workers are shown with blasting equipment used to rebuild the road through Willard Brook State Forest in 1932. The depression hit Townsend in the early 1930s. The CCC built barracks and other facilities north of Turnpike Road in West Townsend, providing work for area carpenters and laborers. Before closing in 1941, the CCC reforested West Hill and made major improvements to Willard Brook State Park. (Courtesy of Robert Tumber.)

The CCC camp was reopened during World War II. Two hundred British sailors, who had helped sink the German ship *Bismark*, arrived to use the barracks for rest and relaxation. They were welcomed by the community, especially by the young women, who were charmed by the sailors in their white summer uniforms. Here Mildred Smith presents an American flag to the British Royal Navy men stationed there. (Courtesy of Mildred Smith.)

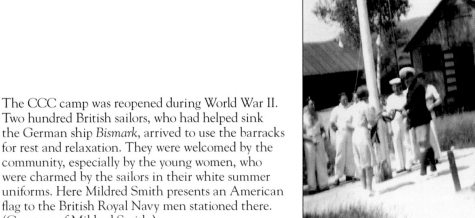

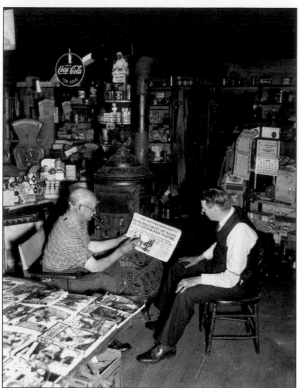

William MacMaster (left) and Samuel Woods examine the World War II headlines in Woods' General Store across from the town hall. Residents followed the war news avidly, concerned both about home defense and the welfare of their military men and women. By the time the war ended, more than 300 townspeople had entered the armed services. (Courtesy of Donald Keefe.)

Townsend residents were well aware of their relative proximity to naval stations in Boston and Chelsea, and particularly to Ayer's Fort Devens. In September 1941, 40,000 troops and 2,500 vehicles held training maneuvers in the Townsend area, but the community showed nothing but patience for the disruptive activities. These jeeps are on Greeley Road, and the troops are in the fields at Willard Farm.

Betty Makela Larson is posing on the airplane-spotting tower on Bayberry Hill; 40 townspeople volunteered for observation duty. This spot on Leo Makela's property became the site for some noisy parties, so the tower site was moved to the land behind Spaulding School. Nearly a third of Townsend's residents signed up to be defense volunteers, working as firemen, automobile mechanics, cooks, and knitters, to name just a few specialties.

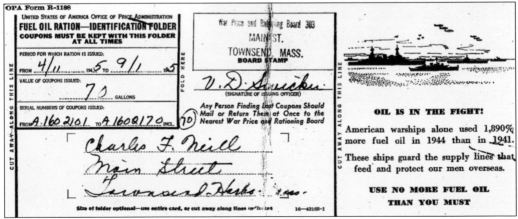

This fuel oil ration slip is representative of the privations that Townsend citizens loyally endured to support the war effort. Gas rationing began in May 1942, and 562 people signed up for cards. In 1943, more than 2,000 ration books for food were issued to the local population, with additional sugar rations allocated during canning season. Townsend residents exceeded their quota of war bonds bought and blood donated.

From horse-and-buggy days onward, disastrous road mishaps were a continuing risk. The early passion for the "horseless carriage" was tempered by flat tires, rough dirt roads, and accidents. This early automobile, labeled "Lovejoy's Auto," has gone off the bridge on Wheeler Road. It is an early, open-top touring car with right-hand drive. The round tank on the side possibly holds acetylene for the headlamps.

Once businesses started shipping some of their stock by motorized vehicles, damage to vehicles was not the only financial hazard in the event of an accident. The Fessenden Company sent two trucks loaded with barrels to Boston every day. The Fessenden trucks shown here seem overloaded, and one has overturned, spilling its contents onto the road. (Courtesy of Donald Keefe.)

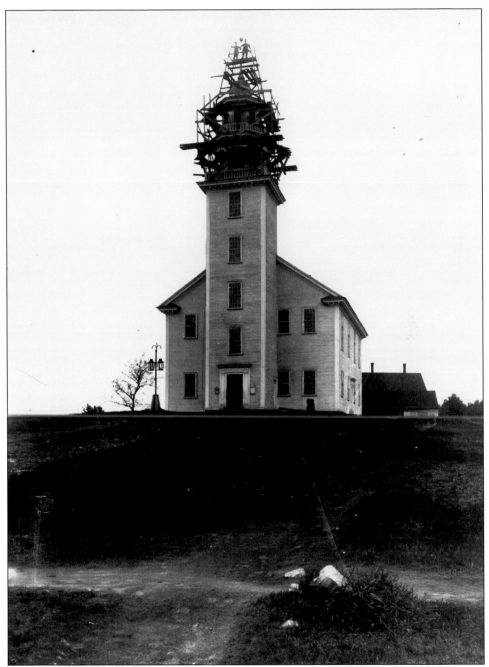

Natural disasters were part of life in Townsend, especially those that were weather related. Even a bad rainstorm could produce devastating lightning strikes and fires. The Methodist church steeple has been hit by lightning in this early picture taken about 1877. Even repairing the damage at such a height posed it own risks. Levi Richardson and his father are standing on the top of the scaffolding, working to effect repairs. This building, which was the second meetinghouse, was originally built on Meetinghouse Hill. After it was moved to Townsend Center in 1804, the tower and steeple were added. An early oil lamppost stands on the left, and the horse sheds can be seen in the rear right of the picture.

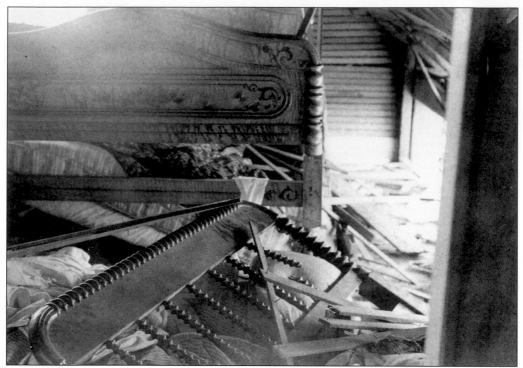

Private homes were not immune to storm damage, as this interior view illustrates. Lightning struck the Hosley house on West Elm Street about 3:00 a.m. one morning in 1895. The bolt of lightning not only knocked Mrs. Hosley out of this bed, but the force rolled her under it. Amazingly, she and her children were unhurt.

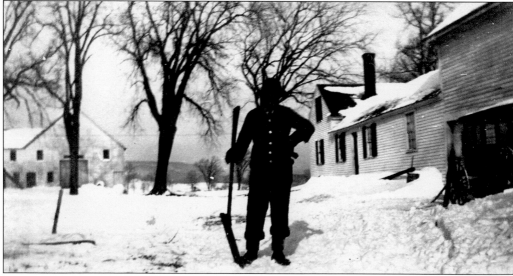

New England winters can be brutal, producing ice and snowstorms that wreak havoc on any town. The March blizzard of 1888 left Townsend residents stunned, as did the blizzard of 1978. Even smaller snowfalls require cleanup. In this photograph, Frank Weston, who owned a harness shop in the Park Hotel arcade, stands in front of his house at 518 Main Street, West Townsend, a snow shovel in hand.

A terrible forest fire in April 1927 destroyed the Stickney homestead on Townsend Hill, leaving only these chimneys. While the fire raged, George Tenney had to force Harriet Stickney out of her home to safety. Timber burned for 23 square miles. Hundreds of firemen from Townsend and surrounding communities, joined by 400 men from the Boston and Maine railroad, fought the fire that was caused by a spark from a train.

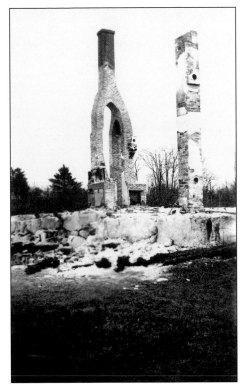

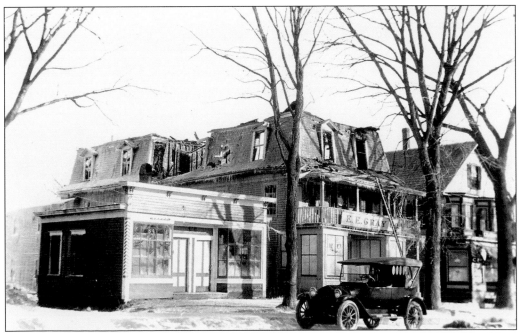

Fire has damaged or destroyed many wooden structures in town. It ravaged the Funaiole building on Main Street in Townsend Center on December 21, 1924. The three-story building had a store on the first floor and two apartments above. The third floor was razed, leaving two stories, with the post office later situated on the first floor.

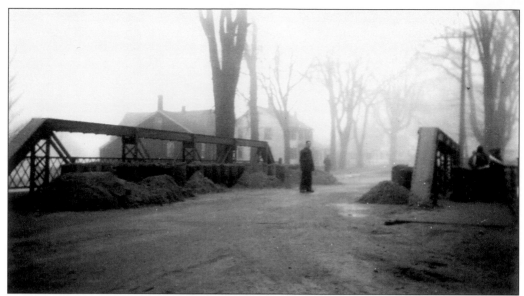

The Squannicook River floods regularly, but March 1936 saw the worst flood. An earthen dam in Ashby gave way to waters swollen from rain and melting snow. Enormous chunks of ice slammed into Townsend's bridges and vulnerable buildings. The Burpee paint shop on Highland Street smashed into Townsend Center's bridge, which was saved by barrels of sand placed on the top and sides. These men are surveying the damage.

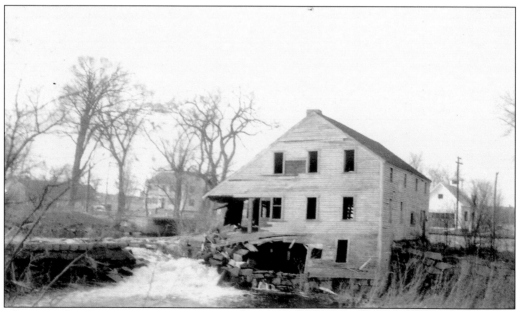

The same flood washed out much of the south side of the Cooperage in Townsend Harbor, where some of the worst damage was done. The gristmill and leatherboard factory were also badly damaged by the dangerous waters. The water level rose to four feet on Main Street, and even worse, South Street's iron bridge was swept into the river. Townsend's schools were closed for almost two weeks.

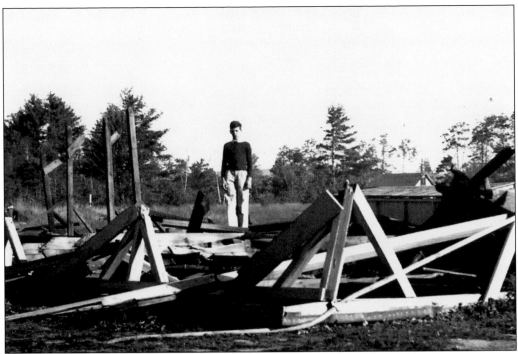

The hurricane of 1938 lashed across most of New England, leaving few towns untouched, including Townsend. This is all that was left of the three-section, covered grandstand at Fessenden Field (behind Spaulding School) after the hurricane hit. The backstop was totally flattened. A much smaller section of bleachers were built later to replace the grandstand. (Courtesy of Donald Keefe.)

Townsend Common shows some of the damage to trees from the hurricane of 1938. Hundreds of trees, especially along roads and in yards, were uprooted and thrown about by the savage winds. Henhouses, essential to the numerous poultry farmers in town, were overturned throughout the town.

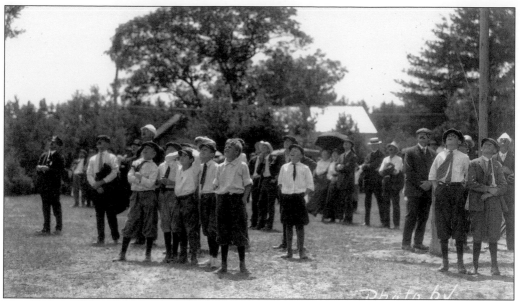

Children often view experiences differently from adults. These little boys from 1919 are watching Lieutenant Moffett's plane that crashed within minutes, or perhaps even seconds, of this captured moment. Fortunately no one was hurt, but the rapt expressions on the children's faces suggest that there were thrills to be found in impending disaster. No doubt the children went home eminently satisfied with the day's unexpected excitement.

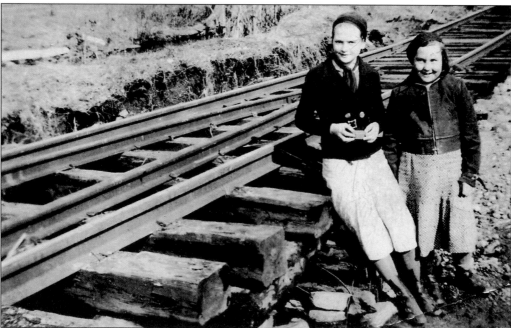

It was cruel coincidence that the 1936 flood and the 1938 hurricane struck during the difficult Depression years. Yet many Townsend residents have only happy memories of their childhoods during that time. Charlotte (Keefe) Newcombe and Ruth (Richards) Smith stand by Townsend Harbor's flood-damaged railroad bed in 1936. Their young faces seem untouched by the trials of adversity. (Courtesy of Charlotte Newcombe.)

Seven

PEOPLE WHO SHAPED THE TOWN

More than geography, boundary lines, or natural resources, the people of Townsend shaped their own town. The town's history remains gray and static, until it is colored and animated by the individual and collective personalities of the townspeople. Townsend had notable and prominent citizens, but the average person contributed equally to the town's development. The eccentric, the entrepreneur, the housewife, the student, and the laborer were all important. Minnie Knight (1865–1959), shown pumping air into her bicycle tire, was a classic New Englander: strong-willed, resourceful, and independent. Her favored mode of transportation was the bicycle, although Townsend-born author Richard Smith reported that her son, Harry, had to discourage her from buying a motorcycle in her elder years. Minnie was often seen riding her bike to the post office in Townsend Harbor. This picture was taken in 1948, when she was 83 years old.

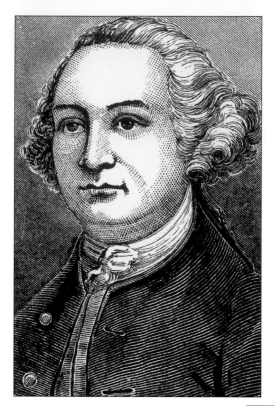

Henry Price (1697–1780) is credited with bringing Masonry to America in 1733. He lived in Townsend during his later years, from 1761 until his death. Masonic officials moved his remains from the Old Burying Ground to Fessenden Hill in 1888, placing a memorial plaque on the site. A delegation of Masons usually arrives in Townsend each May to honor Price, America's Masonic patron and founder.

Letty Amanda Strout (1884–1977) was 10 years old when this photograph was taken. Daughter of Harriet Reed Strout, she was the fourth generation of Reed women to own the family homestead in Townsend Harbor. After graduating from Wellesley College, she married Walter Proctor and raised two sons, Hildreth and Robert. Summers were usually spent at the homestead, before and after Letty Strout Proctor inherited the property in 1942.

Well-known artist Winslow Homer often visited West Townsend to see his brother Charles and sister-in-law Martha. The village's pastoral beauty inspired him to paint at least one picture in West Townsend, *Girl with Laurel*. Fannie Sanders, a 14-year-old neighbor of Charles, is believed to have been the model for Winslow Homer's 1879 painting.

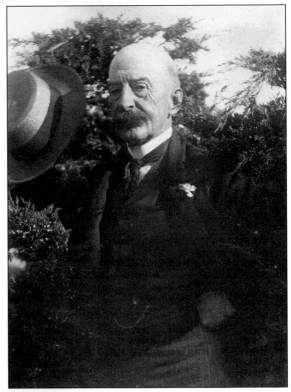

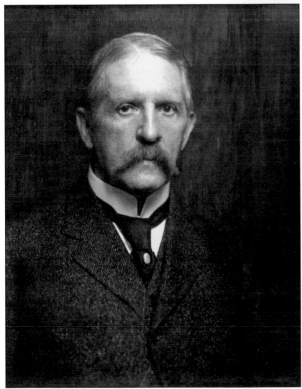

Charles Homer was a chemist who married Martha French of Townsend, the daughter of well-to-do businessman Abram French. Homer's work at the Valentine Varnish Company (he developed ValSpar Varnish) kept him in New York for much of the year. However, his wife's ties to Townsend led Homer to purchase their elegant home in the village, where they spent as much time as they could.

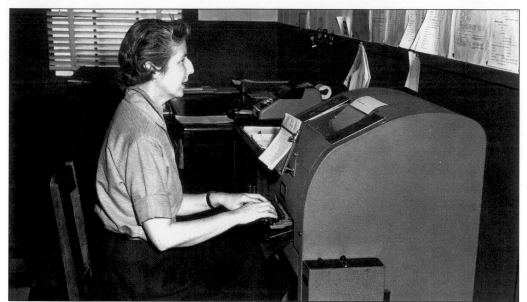

Elsie Lowe wrote a weekly newspaper column, "Along Main Street," for the *Townsend Times*. For 37 years, Lowe kept residents informed on local matters, employing a cheerful, conversational style. She developed a deep interest in town history, writing historical articles and amassing an impressive collection of research notes and historical materials. She is shown here in 1961, working at a Teletype machine for the American Red Cross at Fort Devens.

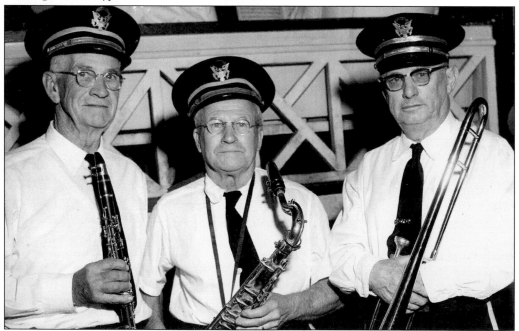

Traditional summer band concerts are still held on the town common. Generations of residents have had their spirits stirred and lifted by the music that soars from the bandstand at twilight. Band members featured here are, from left to right, Robert Copeland, clarinet; Sanford Johnson, saxophone; and Donald Shattuck, trombone. After Copeland became the band's conductor, exuberant and appreciative listeners would blow their automobile horns at the end of each piece.

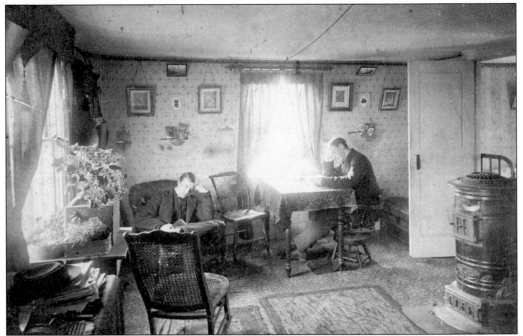

This undated photograph is labeled, "George A. Wilder and ? Hildreth, class of 1883." The men appear to be studying. Graduation from the Townsend High School required passing a stringent entrance examination and mastering a challenging curriculum. Graduating classes were very small, but the men and women who succeeded often played significant roles in town. Wilder (1859–1932), for example, founded the Squanicook Printing Company in 1895, printing countless town publications until 1922.

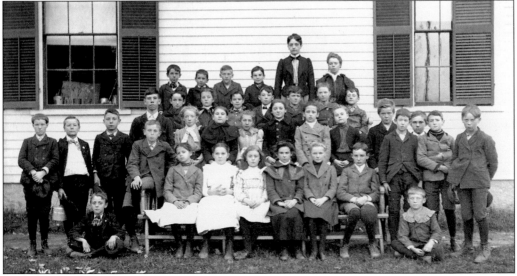

Townsend's teachers exerted a huge influence on Townsend by shaping the minds of schoolchildren. Perhaps a teacher or two "used little boys' heads as a drum for her stick," (*Memoirs*, William O. Taylor), but Clara Craig (standing behind her students at the center) was not one. She spent her entire teaching career in Townsend. Merton Jefts, a former student, considered her "the finest and most dedicated teacher . . . Townsend ever had."

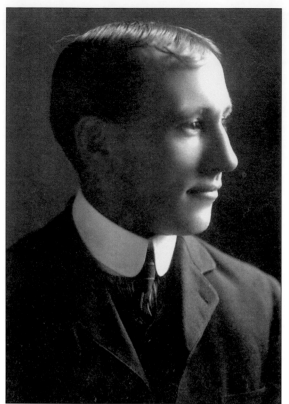

Galen Proctor (1871–1964) hailed from a civic-minded family. His home was the 1773 Proctor Homestead in Townsend Harbor, where he worked as a farmer and lumber mill owner. Proctor variously served as assessor, overseer of the poor, register of voters, and selectman. Townsend's welfare has always depended on individuals like Proctor, willing to donate time, talent, and expertise to benefit a larger good—the town's well-being. (Courtesy of the Proctor family.)

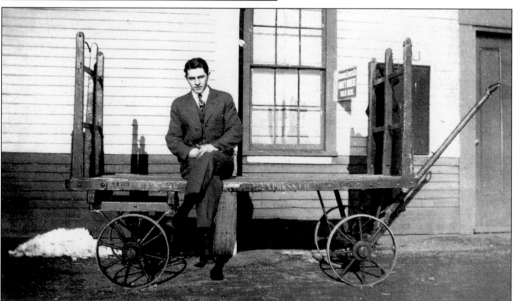

Michael Keefe's sons, Richard, Stephen, David, and Cornelius, were also civic-minded, devoting much of their lives to both paid and volunteer work that enriched the town. Perched on a baggage cart at the Harbor Depot is Cornelius Keefe, around 1917. He was cashier at the Townsend National Bank in Townsend Center. Keefe served on the school committee when Spaulding Memorial School was constructed and opened. (Courtesy of Donald Keefe.)

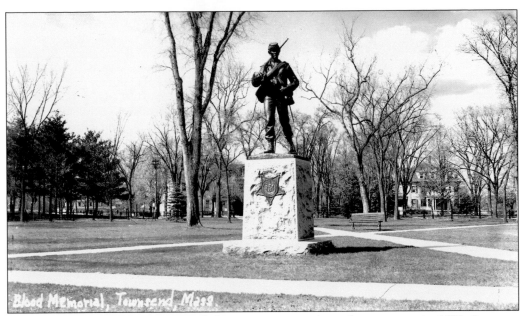

Blood Memorial, Townsend, Mass.

The Civil War statue in Townsend Center was erected on the common in 1932. It was a philanthropic gift to the town to memorialize the men who fought in the Civil War. While philanthropists are traditionally thought of as wealthy, prominent citizens, John Birney Blood, who left $10,000 for the memorial statue in his will, was neither. A Civil War veteran himself, Blood lost a brother in that conflict.

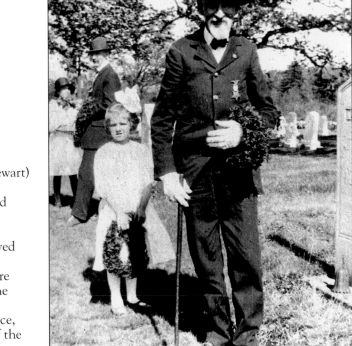

Blood stands with Lillian (Stewart) Spaulding at a Memorial Day celebration. He suffered a head injury in the war, and was viewed as eccentric, perhaps even unbalanced. Since he lived in poverty, townspeople were astounded to learn he left more than $10,000 in his will for the monument. If Blood lived an impoverished lifestyle by choice, his act of philanthropy was of the highest order.

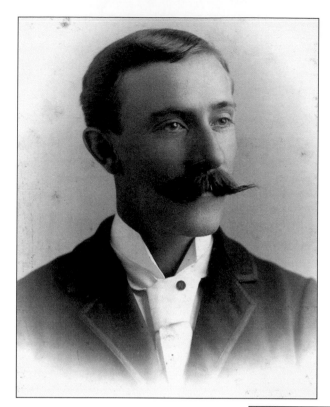

Clergymen of all denominations have been an essential part of Townsend's development. Leopold Nies, a Texas student, was recruited in 1894 as pastor for the Methodist Church. The congregation embraced Nies, enchanted by his energy and charm. He returned to serve "the church on the hill" in 1936, but died in 1937. His daughter wrote *In My Father's House*, a record of his ministry that included the Townsend years.

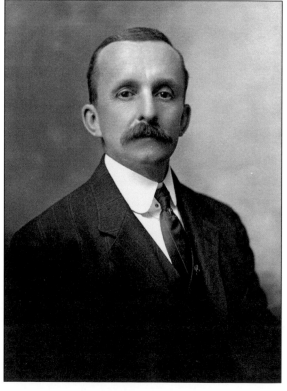

Townsend's history boasts many country doctors, but few were as beloved as Dr. Richard Ely (1869–1952). His humanitarian career spanned half a century, and he is credited with delivering 1,100 babies. Traveling first by horse and buggy, and later by automobile, he made house calls to tend his patients and calm anxious families. Dr. Ely, originally from Vermont, married Eva Sherwin, a local girl who quietly provided food to families in need.

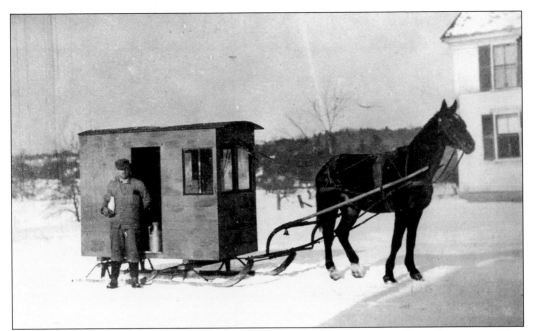

As reliable as the sunrise, the milkman delivered fresh milk to Townsend's residents, regardless of weather. Milk delivery was a reassuring part of ordinary life. In winter, the vehicle would be mounted on sled runners; in better seasons, it sat on large wheels. A truck such as this one often provided an additional service—as school barge, transporting children to and from the schoolhouse. (Courtesy of Gary Shepherd.)

Townsend produced its share of inventors and inventions, but arguably none more unique than Frank Conant and his "tail-still." Clearly tired of being whipped by a coarse tail when milking an annoyed cow, this farmer-turned-entrepreneur set out to solve the problem. He manufactured the device shown, designed to attach to the cow's hind leg. The packaging proclaimed, "Makes Milking a Pleasure. Holds the Cow's Tail Still." The ingenious device cost 50¢.

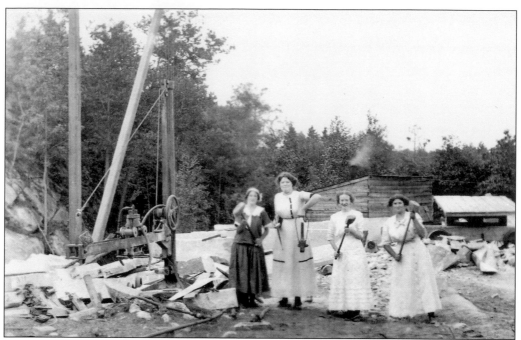

These women were known as the Stewart Sisters in Townsend. Shown here posing with rock hammers at Rusk Quarry are three of the sisters, from left to right, Flora, Elizabeth ("Bessie"), Ann Doherty, and Sadie. Raised to work hard and appreciate life's simple pleasures, the women wove their colorful personalities into the fabric of the town. Sadie was particularly independent, growing her own vegetables and chopping wood well into her elderly years.

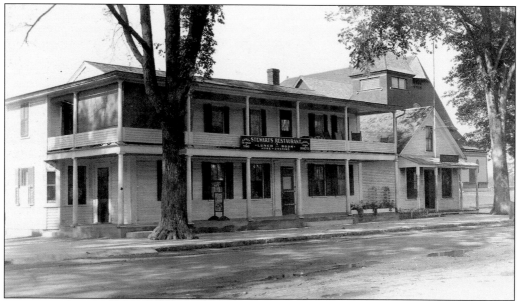

In 1922, Sadie and Bessie Stewart opened their Stewart Sisters' Restaurant at 268 Main Street. The building had been constructed as a residence early in the 1800s and was later adapted for business use, serving variously as a store, bicycle repair shop, and dairy bar. The two sisters purchased the building in 1923, operating their busy restaurant until 1947.

The customers who patronized the Stewart Sisters' Restaurant were not the elegant diners portrayed on the restaurant's business card. Schoolchildren came for lunch, laborers for a hearty, reasonable breakfast, and everyday townspeople for an inexpensive home-cooked meal. During the terrible fire of 1927, Sadie made coffee and sandwiches "by the bushel" for weary firefighters and anxious residents for the six days that the fire raged.

Roland Hall, of Brookline Road in Townsend Center, ran his own unusual business. There were several silver fox farms, or ranches, in Townsend from about 1915 until roughly 1936. In this photograph, taken around 1935, Roland Hall is hand-feeding one of his foxes in a fenced-in area. Fences had to be buried deep enough so the foxes would not dig their way out. Pelts brought in roughly $25.00 each.

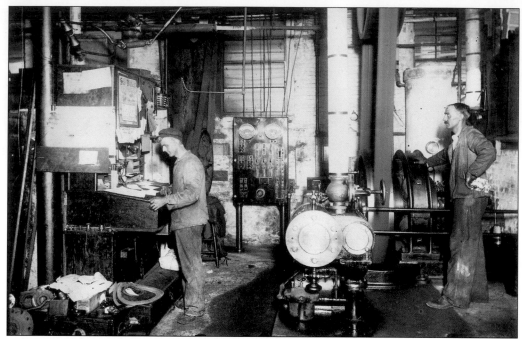

This view depicts the daily work in the Fessenden's factory engine room (or possibly the room adjacent to it) in the late 19th century. The engines generated power for the machinery that produced barrels of various sizes. Factory work, as it really was, is reflected in the grease-streaked face of the worker on the right. Neither worker's identity is known.

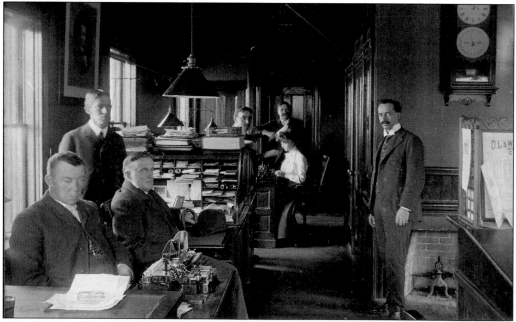

The interior of the Fessenden Company office is shown in a photograph from about 1900. Seated on the left are Julian Eastman and Robert Fessenden, with an early model typewriter nearby. Standing behind the two is Fred Fessenden. This office is located on what is now Center Street and was later converted to a residence. (Courtesy of Donald Keefe.)

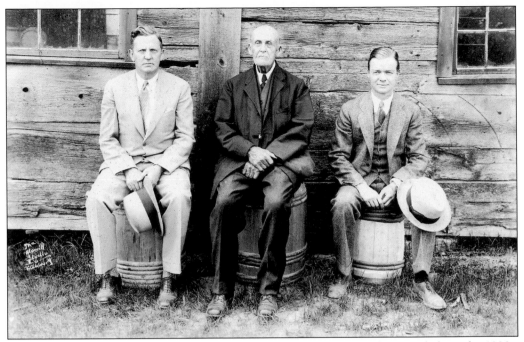

Three of the Fessenden Company's prominent figures pose here in a photograph from the 1920s, from left to right, owner Robert Fessenden, Asa Tyler, and Stanley Fessenden. Tyler worked for four generations of the Fessenden family before his death in 1934. Townsend historian Richard Smith wrote that Tyler's life "seemed to stitch together the old and new Townsends." Production was high and the company was continuing to grow at the time of the photograph.

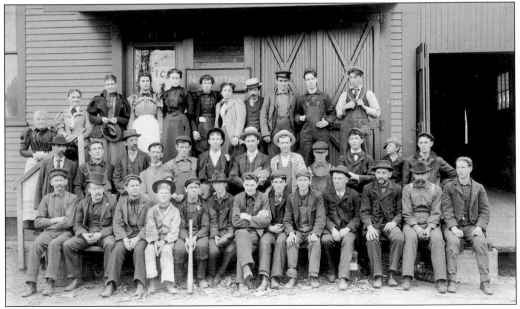

Spaulding brothers leatherboard mill workers and office personnel pose in impressive numbers in front of the office. It was hot in the mill, and the work was heavy. Mill workers had to carry the huge, still-wet, finished sheets of leatherboard across Main Street, laying them out on the ground to dry. The mill's steam whistle governed the workers' days.

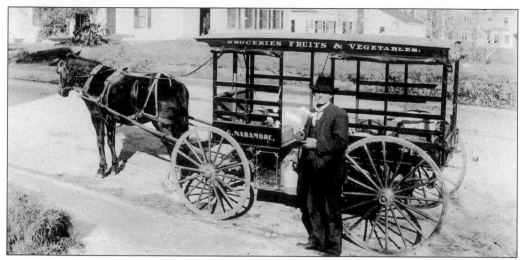

The itinerant peddler was a familiar sight in rural New England, from the early days into the 20th century. He brought news, gossip, and a range of goods, from pins and tinware to fresh produce. G. Naramore, shown here around 1900, was one such peddler. Kabatchnick, another peddler in Townsend, was known for preferring to deposit cash in his horse's collar rather than in the bank. (Courtesy of Donald Keefe.)

Men who felled the trees often lived in shanties mounted on wheels, until their work in the woods was done. They, and the men who hauled the heavy logs from wood lots to lumber mills, were as essential as mill owners in supporting the town's industry. The unidentified driver in this photograph, like all the town's laborers, played a significant role in shaping Townsend into the coopering town it became. (Courtesy of Donald Keefe.)

Eight

PRESERVING THE PAST

An impulse toward American historical preservation emerged during the years after the Civil War. Many records and physical belongings of the early settlers were disappearing; fortunately there were those who moved to remedy the situation. Such a group of concerned citizens in Townsend organized the Townsend Historical Society in 1896. Artifacts and archives were donated to the society; however, the treasures were scattered about in the attics and barns of members before a permanent home could be found for them. For several years, a room in the new library was assigned to the society's use. Meetings and displays were held there until that space was needed for a children's room. Fate, diplomacy, and a mortgage brought the Reed Homestead into the society's care. Along with a large collection of documents, furniture, and photographs, the homestead also contains a room of unequaled folk-art murals attributed to Rufus Porter, such as the one shown in this photograph. A miniature steamboat shares the scene with a variety of sailing vessels. Murals of this type, once a common feature of early homes, were unfortunately destroyed by the application and stripping of wallpaper on the walls.

Rufus Porter, an itinerant folk artist, traveled New England from his home in Maine in the early 19th century. Today his work survives in only a few places. The four walls of an upstairs room in the Reed Homestead display, in pristine splendor, images he created again and again: wine-glass elms, ships of all sizes, and stenciled cottages and mansions.

This monument was placed on Meeting House Hill Road in 1896 to mark the approximate location of Townsend's first schoolhouse. Funds for the monument were raised by schoolchildren and school officials. The one-room school was built in 1747 near the meetinghouse. John Conant and Josiah Robbins comprised the first school committee.

Ithamar Sawtelle (1814–1905) wrote *The History of the Town of Townsend, Middlesex County, Massachusetts, From the Grant of Hawthorn's Farm, 1678-1878*, which he published personally in 1878. An inscription from the words of John Quincy Adams appears on the title page: "Posterity delights in details." Sawtelle attended Amherst College and then served as a teacher, cooper, grocer, and superintendent at Fessenden's mill before taking on the job of recording the details of Townsend's past.

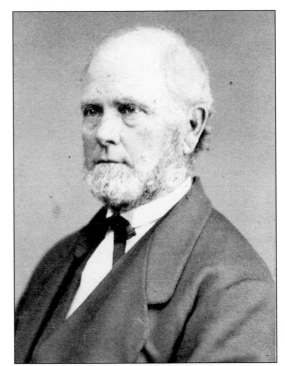

At one point, a downstairs room in the Hart Memorial Library building was designed for the use of the Townsend Historical Society. It was used for meetings and the storage of archives and artifacts. When the library trustees decided to create a separate children's library area, the society was forced to remove its collections.

In the early 1970s, the Reed Homestead, located at 72 Main Street, was purchased by members of the historical society from Letty Strout Proctor, great-granddaughter of Letty and Oliver. Finally the organization's collections had a permanent home. Shown taking part in the mortgage signing are, from left to right, Pearl Russell, Ruth Marshall, Ed West and Hildreth Proctor (son of Letty Proctor).

A small bay window in the rear of the Reed Homestead's kitchen provided Harriet Stout, the last year-round occupant of the house, with a place to nurture her plants during the winter and to grow her seedlings during the spring. After the house was purchased by the society, the window and porch were removed in the belief that the house should be returned to its 1809 appearance.

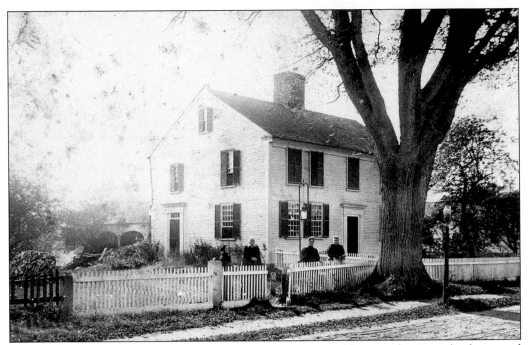

Mary Parker, Harriet J. Reed, Amanda Emory, and Mary Spaulding are shown in the front yard of the Reed Homestead in the late 1800s. A streetlamp appears on the far right. Reed closed the homestead and spent her last years in Mason, New Hampshire, with her brother James. She died there in 1907.

Harriet Reed Strout, daughter of James Reed, inherited an interest in the home of her grandparents Oliver and Letty Reed when her aunt, Harriet J. Reed, died. It is said that when the contents of the house were auctioned off, she bought much of it back again. She was well known for the extensive gardens she created in the Reed Homestead's yard. (Courtesy of Charlotte Newcombe.)

Letty Wilson Reed (1788–1864) is shown in her later years. After she married Oliver Reed in 1809, the couple came to live in the Reed Homestead. Oliver operated a tannery beside the brook until his death in 1839. Letty gave birth to five children, four of whom survived to adulthood: Catherine, James, Harriet J., and Hannah. Until the society bought the property, only descendants of Letty and Oliver lived in the house.

Among the artifacts being preserved by the Townsend Historical Society is this partially finished hat and wooden form. The hat perhaps represents what was once a thriving cottage industry in mid-19th-century Townsend and other New England towns. David Livermore and Daniel Adams fostered the palm leaf hat industry that peaked in 1837 with the sale of 160,000 hats with a value of $22,000.

Society member Mary Wichtermann and clothing expert Nancy Rexford are shown displaying one of hundreds of Reed family garments found in the Reed Homestead. Many items were also donated back to the society by descendants of the Reeds. Cataloging and preserving the clothing collection is an ongoing project of society members.

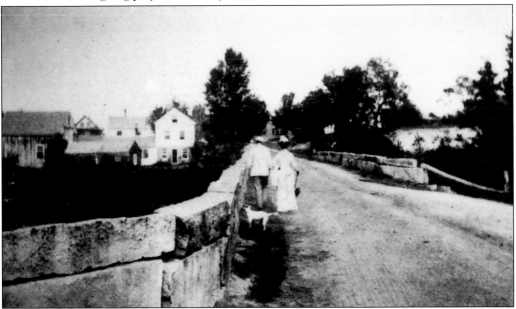

Renowned painter Winslow Homer often visited his brother Charles in West Townsend. He apparently used a camera given to him by Charles as artists do today—to record scenes he might paint. This image is a copy of one of five enlarged photographs, documented as Homer's work, discovered among the society's artifacts. It shows Charles and Mattie Homer crossing the stone bridge in West Townsend.

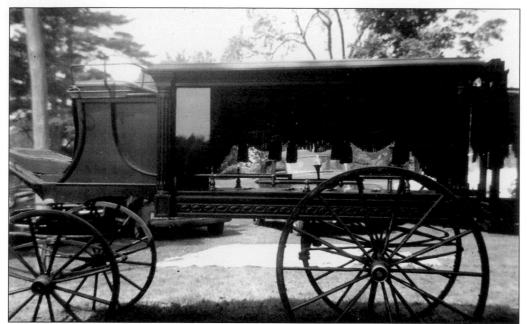

This hearse provided a stylish conveyance for the last journey a person would make on his or her way to eternity. Glass windows provided a view of the casket. The wheels could be replaced with snow runners to provide year round service. Now a property of the Townsend Historical Society, it is on display in the Cooperage.

Townsend's own Richard Norton Smith followed in Ithamar Sawtelle's footsteps with the publication in 1978 of *Divinity and Dust: A History of Townsend, Massachusetts 1676–1978*. A descendant of the Conants, one of the town's earliest families, he is a nationally recognized authority on the American presidency. His is a familiar face on television, where he appears regularly as an expert historian.

The Copeland Cooper Shop, one of the Townsend Historical Society's properties, is a survivor of a cottage industry that was common during the 19th century. During the winter months, farmers often earned extra income preparing barrel parts for the large coopering companies. The 1856 map of the town shows 83 such small cooper shops.

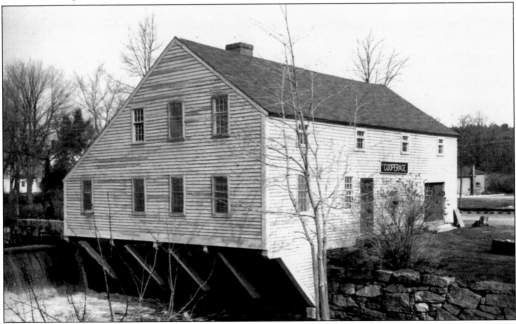

Repairs were made to the smashed sidewall of the Cooperage after the devastating flood of 1936 by the building's owner, the Society for the Preservation of New England Antiquities (now Historic New England). New exterior support beams replaced the lower wall and changed the historic appearance of the building.

Deed restrictions on the society's Cooperage property require an annual inspection of the building by Historic New England. Preservation of historical buildings is an ongoing process, even without the destructive forces of hurricanes and floods. The society's budget must support the work that is needed. The above view of the Cooperage shows a sill being replaced.

The Harbor Church underwent extensive repair and renovation in the 1890s when Charles Emery left funds in his will for the work. The pulpit was removed, and the stage section was added. Emery's will required that the space be named Emery Hall, a title that has not survived. In 1978, when the Harbor Church was owned by Evolution, Inc., a work crew scraped and painted the building that had stood empty for many years.

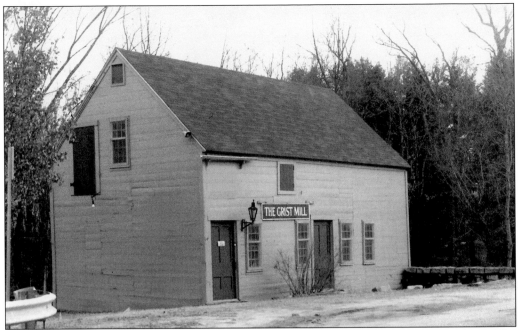

The Spaulding Gristmill today stands alone without the many additions it once had. The property passed from the Spaulding brothers to Historic New England, and then to the Townsend Historical Society. In recent years, it has been necessary to replace the front wall foundation and many of the historic building's sills.

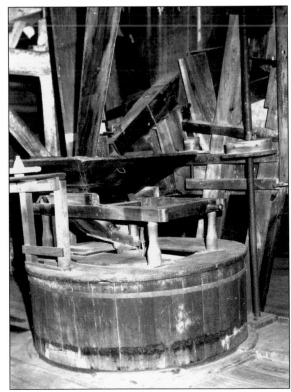

Within this circular wooden compartment are the gristmill's grinding stones that were driven by waterpower to grind corn and grain until 1929. The Townsend Historical Society carries on the challenging job of preserving and restoring the building.

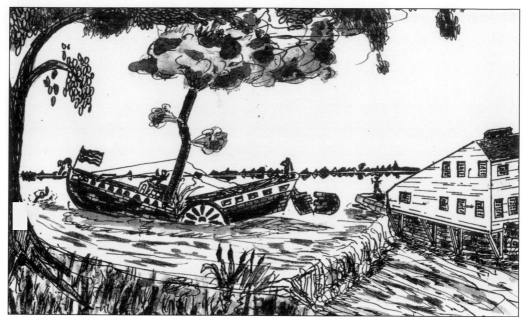

Guenther Wehrhan, a former president of the Townsend Historical Society, drew this cartoon of the mythical Brick Steamer, an imaginary vessel that has been associated with the waters of the Harbor Pond. The myth of its existence has been preserved through several generations of Townsend Harbor residents. It is believed that sometime during the 19th century, when the steam whistle of Townsend Harbor's leatherboard mill blew summoning its workers, someone announced, "Here comes the brick steamer!"

On October 11, 1988, a ceremony was held to dedicate a time capsule buried in Memorial Hall's front lawn. The stone's surface reads, "Beneath this stone is Townsend's 250th anniversary time capsule placed July 1982, to be opened July 2032." Shown left to right are, Joyce Marinel, Dorothy Pillsbury, William Frey, Andrea Wood, Gene Dilda, Mary West, Robert Marriott, Barbara Nixon, and Paul Nixon. The Nixons donated the marble stone.

Deb Jones, one of many highly talented and knowledgeable volunteers, describes the type of food eaten by early settlers. Wearing period garb, she shows how food was prepared on the open hearth and in the beehive oven in the Reed Homestead kitchen. Her presentations are a favorite of schoolchildren and adults alike.

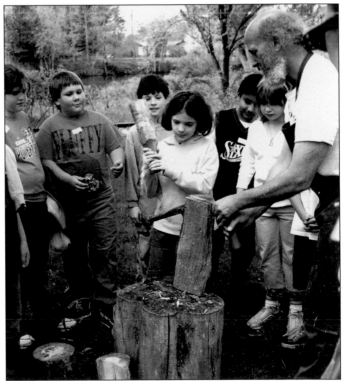

Visiting schoolchildren get a chance to experience many aspects of 19th-century life, including the work of making a barrel with hand tools, starting with logs. At right, veteran volunteer Jonathan Snaith helps a student guide a cooper's tool. These field trip visits of schoolchildren, together with the other programs and exhibits presented by the Townsend Historical Society, are part of the organization's ongoing mission to keep Townsend's history alive.

DISCOVER THOUSANDS OF LOCAL HISTORY BOOKS FEATURING MILLIONS OF VINTAGE IMAGES

Arcadia Publishing, the leading local history publisher in the United States, is committed to making history accessible and meaningful through publishing books that celebrate and preserve the heritage of America's people and places.

Find more books like this at
www.arcadiapublishing.com

Search for your hometown history, your old stomping grounds, and even your favorite sports team.

Consistent with our mission to preserve history on a local level, this book was printed in South Carolina on American-made paper and manufactured entirely in the United States. Products carrying the accredited Forest Stewardship Council (FSC) label are printed on 100 percent FSC-certified paper.

MADE IN THE USA